C000294865

A–Z

OF

READING

PLACES - PEOPLE - HISTORY

Stuart Hylton

AMBERLEY

First published 2017

Amberley Publishing
The Hill, Stroud, Gloucestershire, GL5 4EP
www.amberley-books.com

Copyright © Stuart Hylton, 2017

The right of Stuart Hylton to be identified as
the Author of this work has been asserted in
accordance with the Copyrights, Designs and
Patents Act 1988.

ISBN 978 1 4456 7036 2 (print)
ISBN 978 1 4456 7037 9 (ebook)

All rights reserved. No part of this book may
be reprinted or reproduced or utilised in any
form or by any electronic, mechanical or other
means, now known or hereafter invented,
including photocopying and recording, or in
any information storage or retrieval system,
without the permission in writing from the
Publishers.

British Library Cataloguing in Publication Data.
A catalogue record for this book is available
from the British Library.

Origination by Amberley Publishing.
Printed in Great Britain.

Contents

Introduction

When my publishers asked me to do the Reading volume of their A to Z series of different towns, I knew straight away what I did not want it to be. Reading is fortunate in having the key points of its local history well documented. I did not want this book to be simply those same key points in alphabetical order. I set out instead to find some sidelights into our town's history that might be of interest, and some of which might be new to the reader.

An A to Z format necessarily constrains the author somewhat – how many local history topics beginning with X can you think of, for example? (In my case none, as it turned out, and I had to resort to a little trickery to fill that particular gap.) The format also limits the depth into which I can pursue individual subjects. In some cases I have been able to remedy this by suggesting further reading where a particular topic may take the reader's interest. The format and its space constraints also prevent me giving due acknowledgement to all my sources, with a full bibliography. So I would like to give general thanks here to all those many chroniclers of Reading's history on whose work I have been able to draw.

My particular thanks go, once again, to Reading Central Library and to the unfailingly helpful Katie Amos and David Cliffe, for access to the library's wonderful collection of historic illustrations of Reading. Without them this book would scarcely be possible (or at least very much less visual). Unless otherwise stated all the historic photographs in the book are from their collection and are identified by the seven-figure number in the caption. The Central Library's local studies section also has much more written material on all of the topics I cover, and many more besides. The modern photographs, unless otherwise stated, are my own work, and I would like to thank in particular the churches who allowed me to photograph their interiors.

As for the other illustrations, I have tried to avoid any infringements of copyright in my selection. If I have unwittingly failed in any case, please let me know via the publisher and I will try to ensure that this is remedied in any future editions.

A

Aston, Sir Arthur

In any list of unpopular figures in Reading's history, Sir Arthur Aston (1590–1649) must surely feature near the top. He was from a military family, whose service included acting as mercenaries to the king of Poland. Come the English Civil War in 1642 and King Charles at first refused to employ him because of his Catholicism (Aston had earlier been forced to resign another command for this reason). Only an intervention by Prince Rupert persuaded Charles to change his mind (and this after Aston had made soundings with the Parliamentary cause about fighting for them).

Aston was made commander of the Royalist garrison in Reading, where he quickly made enemies through his authoritarian manner and extortion. His garrison effectively doubled the town's population and he bled the townspeople dry meeting the army's running expenses. He also paid himself a very comfortable salary from the proceeds – so much so that he was able to lend the cash-strapped Corporation money (at interest), which he was then able to extort back from them. He also built extensive fortifications around the town, sometimes using townspeople's own goods and chattels as barricades.

His discipline of his own men was no less controversial; within three days of his arrival he executed three of them and, at one point in his career, one soldier he took against suffered the barbaric punishment of having his right hand sawn (not just chopped) off. To be fair, Aston had some special disciplinary problems with his troops. Some of them were pressed men – captured Parliamentary troops who had been given the choice of changing sides or execution. Part of Aston's loyal forces had to be deployed guarding them.

By April 1643 Royalist Reading was besieged by Parliamentary forces. During an artillery bombardment tiles and bricks were dislodged from a roof, striking Aston and 'breaking his pate' (fracturing his skull). Only primitive emergency brain surgery saved his life, but he was forced to hand over his command. He eventually made a full recovery and later in the war was put in command of Oxford. There he so endeared himself to his own men that a group of them took advantage of a dark night and a dark alley to beat him up. While at Oxford, he also lost a leg in a riding accident.

In 1648 he joined the Royalist forces in Ireland, where he was put in charge of the strongly Parliamentary town of Drogheda. The following year Drogheda was besieged by Cromwell and the Royalist garrison was eventually put to the sword – except, that is, for Aston, who had his brains dashed out with his own wooden leg by Parliamentarians who mistakenly thought the limb contained a secret cache of gold coins. The leg survives to this day.

History has not been kind to Aston. His removal from Oxford was said to have been 'to the great rejoicing of the soldiers and others in Oxford, having expressed himself very cruel and imperious while he executed that office'. Antiquarian Anthony Wood called him '...a testy, forward, imperious and tyrannical person hated ... by God and man'. The Earl of Clarendon, an early historian of the Civil War, said of him 'he had

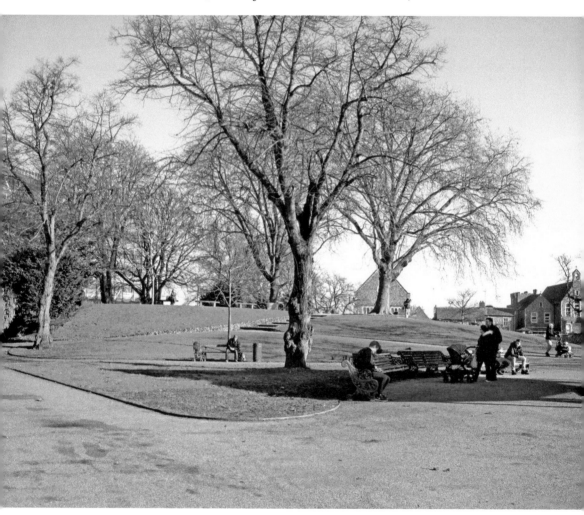

The Forbury mound, thought to be the last remaining part of Reading's Civil War fortifications. A Crimean War cannon used to stand on top of it.

the fortune to be very much esteemed where he was not known and much detested where he was; he was at this time too well known at Oxford to be beloved by any'. He was 'a man of rough nature, and so given up to an immoderate love of money that he cared not by what unrighteous ways he exacted it'.

For more about Aston and the siege of Reading see M. C. Barres-Baker's book of that title.

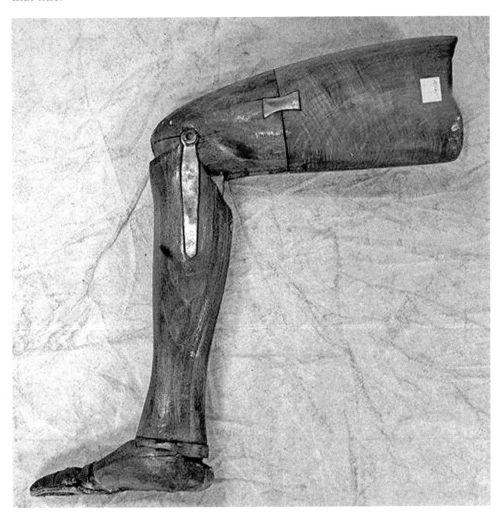

Sir Arthur Aston's wooden leg – also used as his murder weapon (Emlii).

Blagrave Street and John Blagrave

Blagrave Street, running in front of the old Town Hall, takes its name from John Blagrave, born in 1561 at Bulmershe Court and the son of another John Blagrave. He studied at Reading School and St John's College, Oxford (though he never graduated from St Johns), and went on to become a leading mathematician and instrument maker. He wrote four books on the subject and invented various devices for taking scientific measurements.

Blagrave lived at Southcote Manor, which was bequeathed to him in 1591, though he also owned property at Swallowfield and in Reading's Bridge Street. He became noted for his philanthropic works. One of the more controversial of these was the Blagrave Piazza, a covered area built onto the south wall of St Laurence's Church in 1619. It variously provided shelter for the women in the nearby market, somewhere comfortable for the elderly to sit in the daytime and a home for the town's 'instruments of justice', such as the pillory and the ducking stool. More controversially, it was said by night to be the venue for a good deal of vice and depravity.

Architecturally the piazza was not to everybody's taste. While some thought it an attractive feature, John Man (see under H), who rarely had anything good to say about Reading, described it as 'a most clumsy and ill-formed arcade ... erected in defiance of every rule of architecture'. It was demolished as part of a wider refurbishment of St Laurence's Church in 1867, but can be seen in early pictures of the church.

John Blagrave died in 1611. His remains rest in St Laurence's, where an effigy of him may also be seen. He left no direct heirs and Southcote Manor passed to his nephew, Daniel Blagrave. Daniel was a prominent Parliamentarian and MP for Reading, and allowed the Earl of Essex to use Southcote Manor as his Parliamentary headquarters during the Civil War siege of Reading. But his main claim to fame is as one of the signatories on the death warrant of Charles I, and he had to flee the country on the Restoration of Charles II in 1660.

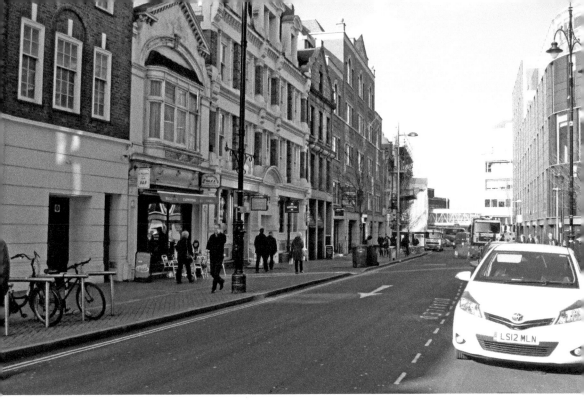

Above: Blagrave Street, named after John Blagrave, Reading's noted mathematician and inventor.

Right: The monument to John Blagrave, which can be seen in St Laurence's Church.

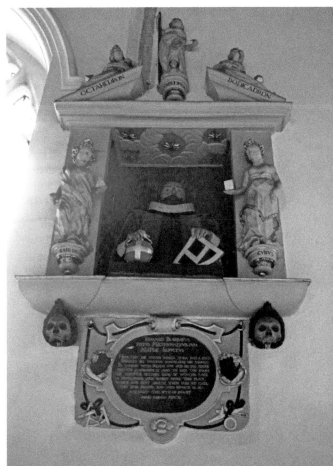

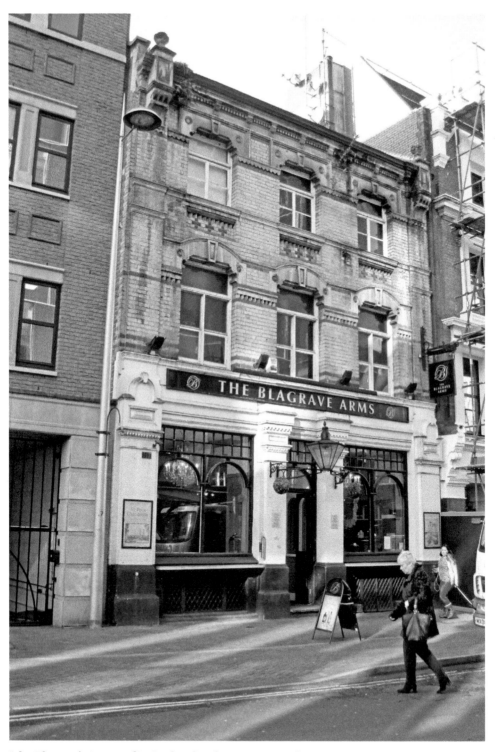

John Blagrave's immortality in ale: The Blagrave Arms, Blagrave Street.

C

Caversham Bridge and a Missing Chapel

Caversham Bridge was said to be the brainchild of some important figures in Reading's medieval history. They included the abbot of Reading, who lived on the south bank of the Thames and, on the opposite bank, William Marshal, the Earl of Pembroke, who served as regent during the childhood of Henry III and, for a time, ran the entire nation from his estate at Caversham Park. The first written reference we have to the bridge is in a document of 1231, which also refers to a boat 'for ferrying poor people over the water of Caversham'. Poor people often could not afford the cost of the tolls commonly charged for passage across bridges.

There are ancient records of a shrine to Our Lady of Caversham, somewhere north of the river. It dated back at least to the twelfth century since, in 1106, Robert, Duke of Normandy, is recorded as giving it a relic of Christ's Passion that he had brought back from the First Crusade. The precise whereabouts of the shrine are a mystery. For a long time it was thought to be part of (or close to) St Peter's Church. Other research linked it to the manor of Caversham, somewhere near Dean's Farm, while early references simply placed it 'somewhere near the river'. More recently, it has been associated with (or should that be mistaken for?) a chapel, also dedicated to St Anne, on the north side of Caversham Bridge. This latter may result from confusion by the local Catholic priest back in 1897.

In fact, Caversham Bridge is thought to have had two chapels – one dedicated to the Holy Spirit on the Reading side and the one to St Anne, whose foundations were rediscovered during the building of the current Caversham Bridge in the 1920s. These chapels would have been there as much for the collection of bridge tolls as for the spiritual comfort of travellers. A. L. Humphries, the bridge's historian, claimed in 1926 that prior to the Dissolution of the Monasteries, the St Anne's Chapel on the bridge housed a number of relics – including a life-sized image of the Virgin May 'plated with silver and bejewelled', 'the blessed knife that killed Saint Edward the martyr' and a piece of the halter with which Judas hanged himself. Some of these items, such as Judas' rope, also feature in the history of the Shrine of Our Lady of Caversham, and it sounds as if Humphries may also have got the two confused.

The Thameside Promenade in around 1899, looking towards the iron Caversham Bridge that replaced its medieval predecessor in 1869 (1224877).

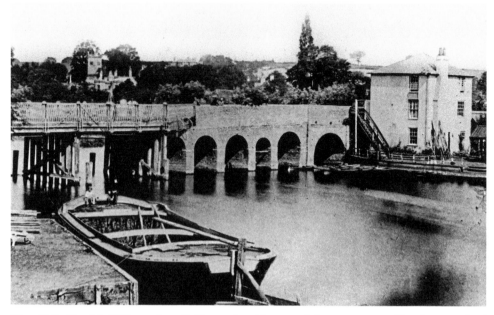

The old 'half and half' Caversham Bridge, only wide enough for one-way traffic, photographed before 1869. When it was replaced, the building on the right had to be lifted up and moved in its entirety (1253976).

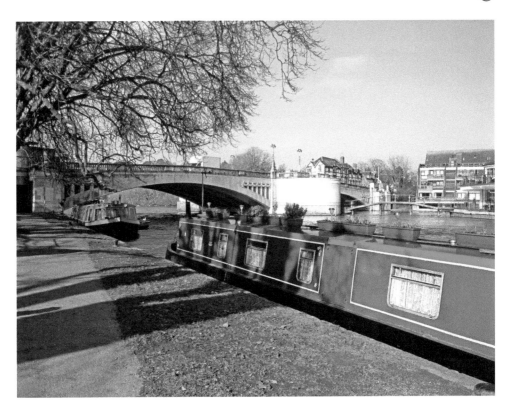

Above: The modern (albeit ninety-year-old) Caversham Bridge, seen from the south bank of the Thames.

Right: The Roman Catholic church on Caversham's South View Avenue has its own modern shrine to Our Lady of Caversham.

Just to add to the confusion, there is a holy well dedicated to St Anne at the top of Caversham's Priest Hill and a completely modern shrine to her in the Catholic Church of Our Lady and St Anne's on South View Avenue. This latter was first mooted in 1954 and now attracts its own pilgrimage traffic (the statue of Our Lady of Caversham in the new shrine wears a gold crown blessed by Pope John Paul II).

Henry VIII's first wife, Catherine of Aragon, was said to have worshipped at the chapel on the bridge in 1532. It was still standing when John Leland made his way across the bridge on his travels in 1536, but had gone by 1714.

D

Reading in the Domesday Book

In 1086 William I (the Conqueror) commissioned a survey of England (and parts of Wales). Its purpose, as explained in the Anglo-Saxon Chronicle, was to establish 'How it was occupied, and by what sort of men ... how many hundreds of hides [hides are a measure of land, in Wessex generally 40–48 acres] were in the shire, what land the King himself had and what stock upon the land; or what dues he ought to have by the year from the shire'.

No equally comprehensive national survey would be undertaken until 1873. It was said to be called Domesday because 'its sentence cannot be quashed or set aside with impunity ... its decisions, like those of the last judgement, are unalterable'. What did the inspectors find when they came to Reading?

It was already a burh, an important town (valued at £48), though not necessarily fortified. It was owned by the king, though extensive parts of it were given to the Battle Abbey (the area of Reading still known today as Battle). These would eventually be recovered by the king in a land swap in 1122, to enable him to present them to the newly formed Reading Abbey. Fifty-nine agricultural plots were listed on the king's estate, sufficient to keep forty plough teams occupied. The surveyors counted fifty-five villeins (peasants in a state of serfdom, their lives largely controlled by the lord of the manor) and thirty bordars (a rank below villeins – scarcely more than slaves). There was an unnamed church (presumably St Mary's) within the town, and four mills and three fisheries along the Kennet.

The main landholding not held by the king was that of Henry de Ferrers, ancestor of the Earls of Derby and one of the nation's biggest landowners. Before 1066 these Reading lands used to be held by King Harold's representative in Berkshire, a man named Godric, but he died at the battle of Hastings. Much of Caversham was held by Walter Giffard, a cousin and loyal supporter of William the Conqueror, who supplied thirty of the ships that carried William and the 1066 invasion force to England. Giffard had huge landholdings in Britain, including large parts of Buckinghamshire, and eventually was made the 1st Earl of Buckingham.

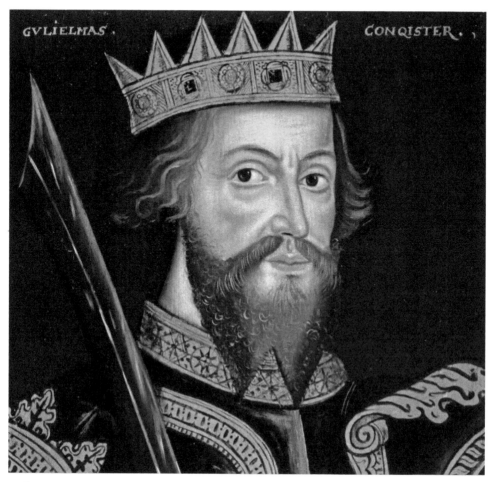

William I (the Conqueror), who commissioned the Domesday Book (wjartuso.wordpress.com).

Reading and Wallingford were the only places in Berkshire listed in the Domesday Book as burhs, showing the town's importance as a trading centre in Saxon times (though Wallingford was, at this time, by far the more important of the two, several times the size of Reading).

Elections

Reading has been returning Members of Parliament since 1295. For a long time the Corporation appointed their unelected choice of candidate. But from 1659 the House of Commons' Committee of Privileges ruled that the franchise should be widened. We will focus on some of the elections of the eighteenth and nineteenth centuries – Reading's golden age of electoral corruption.

The scene was set in 1713 when Felix Calvert, a wealthy brewer, stood for election. He commissioned a huge feast for both the electors and the women of the constituency (the latter a group who did not get the vote for another 200 years). His menu included an ox, nineteen fat sheep, five bucks, three calves and 1,000 loaves, washed down with twenty barrels of beer and fifty dozen bottles of wine.

Two years later the agent of another candidate, William Cadogan, was to be seen in the Black Boy Inn dispensing two guineas 'reward' for each vote cast for his man, and offering to double the bribe offered by any other candidate. For good measure, anyone implacably opposed to the Cadogon candidacy could earn himself three guineas simply by absenting themselves from the election entirely and going off fishing.

But this election was a model of propriety compared with the track record of John Dodd as the town's MP (1755–82). He was in receipt of a government pension, which depended upon him remaining a Member of Parliament, and it was said that he would offer up to thirty or forty guineas for a vote. It was reported at the Abingdon Assizes in 1768 that four verdicts were obtained for bribery in the late election for the borough of Reading and 'divers other prosecutions, upon the same statute, are depending in that Borough'. Several bribed voters apparently had a last-minute attack of conscience when ordered to take an anti-bribery oath at the hustings and confessed to their wrongdoings.

In 1818 the bribery took a liquid form, with John Wayland, one of the candidates, reporting that 'the populace [was] reduced in open day to a disgraceful state of intoxication'. One citizen apparently suffered a fatal overdose of pre-election alcohol. Allies and opponents alike could be plied with alcohol, the aim with the latter being to make them too intoxicated to be able to vote (and preferably for them to be arrested for drunkenness, just to be on the safe side).

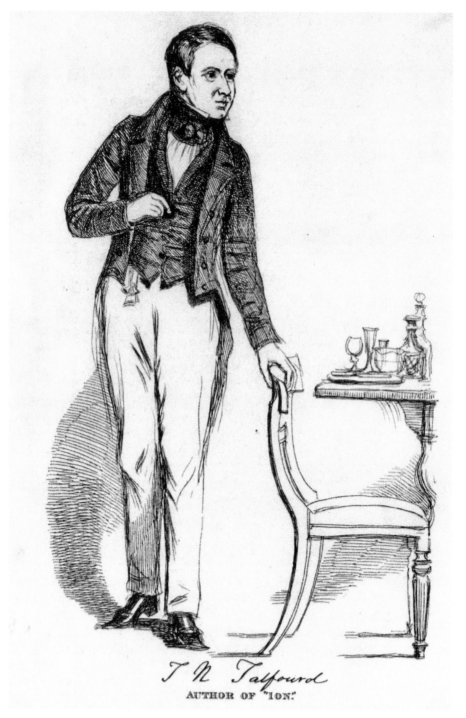

T N Talfourd
AUTHOR OF "ION."

Thomas Noon Talfourd (1795–1854), friend of Charles Dickens, one-time Member of Parliament for Reading and apparently one of the few candidates not to resort to corrupt practices to get elected (1311977).

Violence was a common feature of the hustings and special constables were sworn in at election time to try and keep the peace. But in 1826 it all got out of hand. A fierce fight broke out at the centre of which was a tall, powerful farmer named Webb. He laid out people left, right and centre, but it was not clear at the end whether the pile of felled bodies surrounding him were opponents, or allies who were just in the wrong place at the wrong time.

Even military ordnance featured in the festivities, with a celebratory cannon being fired on the Forbury on election nights. In 1832 the drunken celebrants of the passing of the Reform Act went too far with this. They moved the cannon into the more confined space of London Street and accidentally put twice the recommended charge of gunpowder in it. It blew the cannon to pieces and shattered every window for some distance.

Nothing was too blatant; there were public dinners, cash gifts, cheap loans, grandiose processions and scurrilous lies spread about one's opponents. As the *Daily News* reported in 1849, 'Reading has got a dishonest reputation. With the single exception of Mr Talfourd, not a member has sat for this town for years except by the well-understood purchase of the voters'. (Thomas Noon Talfourd was Reading's MP from 1835 to 1841 and 1847 to 1849. He was a close friend of Charles Dickens, who dedicated his *Pickwick Papers* to him.)

The Floods of 1947

Before the floods, there was the freeze. January and February 1947 brought some of the coldest weather on record, with parts of Reading experiencing temperatures of minus 12 degrees centigrade. There were winter sports in Prospect Park and skating on Whiteknights Lake.

The government, already near bankrupt from the war, struggled to cope. Fuel supplies were at austerity level even before the big freeze and the authorities struggled to deliver what little there was through the ice and snow. There were 50 per cent cuts in fuel supplies to industry and thousands of jobs in Reading were put at risk. Those reliant on gas or electricity also faced cuts, as coal supplies failed to reach power stations and gasworks. Improvisation was the order of the day, with some homes or workplaces lit by car headlamps or candles. It all got political, with anti-government slogans appearing on walls – like 'socialism = no warmth, no jobs and no hope' – and local MP Ian Mikardo looking to blame the coal shortage on the pre-nationalisation mine owners' failure to invest in the pits.

The thaw was swift and catastrophic. The ground did not have time to thaw out as the deep snow melted, preventing the water soaking into the soil and leaving it to pour into the rivers and streams. Reading had known floods before – in particular those of 1894, until then the highest on record. But those of 1947 would, in some places, exceed even these record levels. The Thames was several feet above its normal level, having risen by 15 inches in a few hours. Almost the whole of Lower Caversham was under water and the course of the river had been lost beneath a gigantic stretch of turbulent water between the railway embankment in the south and the Warren, South View Avenue and Lower Henley Road to the north.

Some 1,600 houses were affected by flooding, mostly within the area bounded by Westfield Avenue, South View Avenue and Star Road. Around 200 of the aged or infirm were evacuated and most of the rest stayed at home, marooned in the upper floors of their houses. A convoy (or should that be armada?) of lorries, boats and army amphibious vehicles supplied them with hot meals and drinks, prepared by the Women's Voluntary Service.

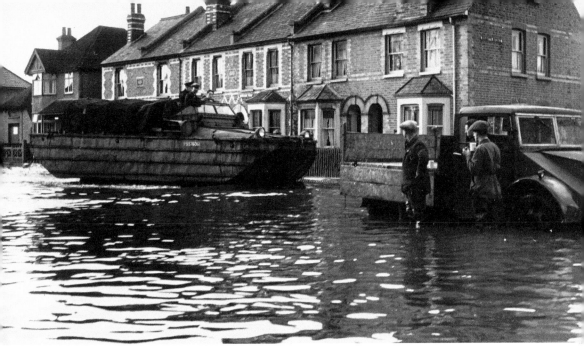

Gosbrook Road, Caversham, during the floods of 1947. A military amphibious vehicle is being used to deliver essential services to trapped flood victims (1204978).

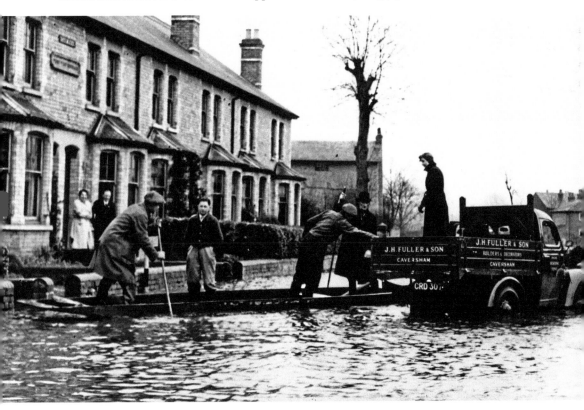

Star Road, Caversham, during the 1947 floods. Civilians join the military in trying to help the flood victims (1204996).

The most surprising shortage throughout it all was water. The floods were threatening to overtop the flood defences at Fobney and Southcote waterworks and pollute the supply. Customers were asked to reduce their consumption and to boil drinking water before use. Local shopkeepers delivered milk, bread and other essentials, and even the postal service continued, delivering letters to upper floors on the end of a long pole by punt. An emergency telephone line gave subscribers at least a limited communication with other parts of the town. But most schools were shut and greyhound racing at Norcot was cancelled after the hare drowned.

There was more discontent as the waters subsided. The quarter hundredweight of emergency coal (around 13 kilograms) given to each flooded household to help dry out their sodden property was deemed woefully inadequate by the public, especially when householders had to collect it from the depot themselves and supply their own sack, but at least the mayor's hardship fund supplied each household with a bar of soap.

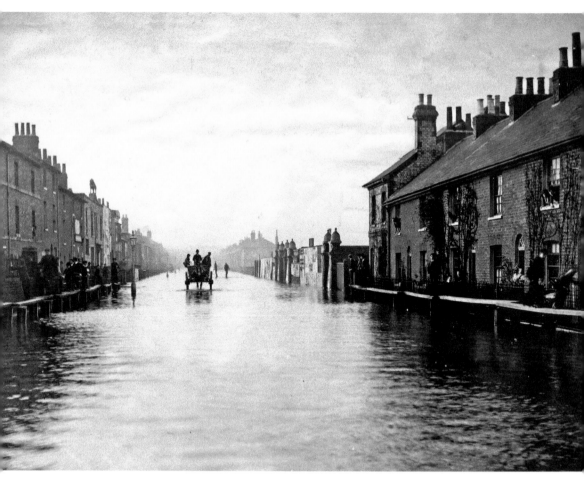

1947 was not the only year of flooding in Reading. This is Great Knollys Street in 1894. Note the duckboards along the pavements (1242857).

G

Great Western Railway

Many books have been written about Reading's relationship with the railways. In this short space we will concentrate on the initial opposition to the building of the railway in the 1830s.

The inspiration for the Great Western came from the merchants of Bristol, who saw (and envied) the success of the pioneering Liverpool & Manchester Railway. They too wanted something quicker, cheaper and more reliable than the roads and canals to transport their goods to their main market in London.

Any thought of generating trade from intervening stops (like Reading) along the line was very much secondary, and some of its opponents seized upon this. As one Reading man put it: 'Here is no manufacture, nor is it within the range of possibility that any can flourish here; nor can the trade of the place be improved; it now supplies the country around with everything, and more it cannot'. (This as Reading's three B's – beer, biscuits and bulbs – were starting on their way to becoming nationally important manufacturers.)

Others feared the railway lowering the tone of their neighbourhood. First there would be the reign of terror forecast as armies of lawless navvies descended upon Berkshire, to build the line. In their wake would come all the immoral dregs and criminal classes of the metropolis, intent upon crime, or polluting the morals of local citizens. Having committed their misdeeds, the railway would give them a rapid escape route back to London.

Then there were environmental concerns. Navigation of the Thames would be impeded and the railway bridges crossing it would act as dams, causing flooding upstream. The Thames itself would be neglected as a transport corridor and would silt up. Farmers' landholdings would be fragmented and when (as they confidently predicted) the railway failed, their earthworks and other structures would remain as derelict and neglected blots on the landscape. Similarly, the railways would (it was believed) afford an easy means of escape through which the pupils of Eton College could make their way to the fleshpots of London. The college was able to use its influence in high places to extract elaborate and expensive security measures against this from the railway company.

Then there were the wilder claims for the effects of the railways. They would stop hens laying and cows producing milk. Horses would become extinct as the need for them declined and birds flying through the locomotives' smoke would be asphyxiated. Similarly, human passengers travelling at such unnatural speeds would be unable to breath and would expire.

But the arguments for the public utility of the railway were overwhelming, and the railway secured its parliamentary consent in August 1835. Reading saw its first rail services in 1840.

Those wanting a more detailed account of how the Great Western came to Berkshire could refer, for example, to the book of that name by Daphne Phillips, or to chapter 14 of my History of Reading.

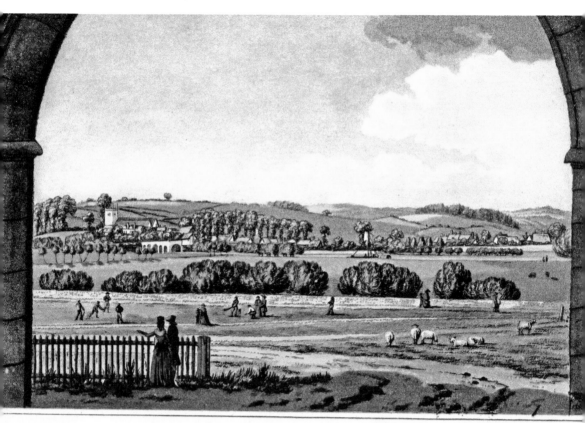

VIEW of CAVERSHAM, through the GATEWAY.

N.º 8

A view from Charles Tomkin's Views of Reading Abbey (1791). It shows Caversham from the Reading Abbey gateway, before Brunel's railway embankment blocked it. The 'half and half' Caversham Bridge can be seen in the centre of the picture (1205201).

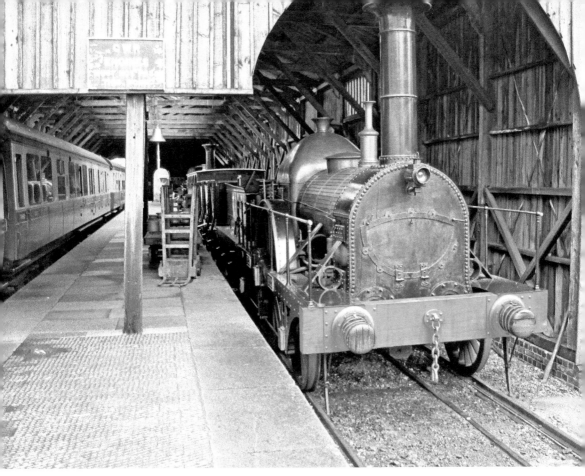

Fire Fly – an exact replica of one of the broad gauge locomotives that took part in the opening of the Great Western Railway to Reading in 1840. It can now be seen at the Didcot Railway Centre.

Historian – John Man

Reading has had a number of chroniclers over the centuries, but one of the most interesting and controversial of them made his anonymous appearance in 1810. To give his book its full title *The Stranger in Reading, in a series of letters, from a Traveller, to his Friend in London* appears to do what it says on the cover, by giving the reactions of a person newly arrived in the town to the delights of Georgian Reading.

The truth was very different. The author was quickly revealed, mainly by several of his detractors (of whom there were plenty), to be one John Man, who had been resident in the town since 1770. He had worked as a teacher in William Baker's Academy and running a waterborne transport business. So he knew the town, its environment and its political and religious institutions intimately, and scarcely had a good word to say about any of them.

Most descriptions of the town at this time tended to be almost fawning in their praise of it. Take William Fordyce Mavor's almost contemporary *General View of the Agriculture of Berkshire* (1813) for instance. He found Reading 'delightfully situated' and the houses 'well-built and commodious'. He praised its 'air of gentility' and concluded that 'there is not a country town in the kingdom that unites so many charms and advantages to persons of independent fortune and cultivated minds'. Small wonder, then, that locals bridled at Man's altogether less favourable views. For example, he savaged the town's:

People: 'it is surprising, that in so high-spirited a town as this, the system of begging should be universally practiced among the lower orders. If you ask one of these the time of day, you are immediately called upon for charity'.

Hygiene: he describes every house in Castle Street having a 'pretty little dung-heap' in the street outside, providing a source of food for the many pigs that apparently roamed the streets without check.

Politics: 'a seat in Parliament, for this place, does not cost the successful candidate less than four thousand pounds, and this without any man actually receiving a farthing by way of a bribe'.

Entertainments: Henry Thornton's theatre in Friar Street was said to be performing to near-empty houses, due to the bigotry of the Methodists and 'the immoderate thirst for gain that pervades every class of shopkeeper'.

A favourite hobby horse of his was the paving and general condition of the town's streets, and it was said that his barbed criticisms brought forward some improvements in that direction. Here is part of his description of Silver Street, '…though there is on one side, for a small distance, a spacious piece of flat pavement almost four inches wide, the rest is so miserably pitched with vile flints, placed with their sharp points upwards, that it is almost impossible for a foot passenger to make his way over them without either cutting his feet or breaking his legs in the attempt'.

One of Man's critics called him 'a sinner against style, fact and principle … such works must perish … he proves himself … to be an infidel of the basest sort'. Yet Man's critical views have survived at least as well as most of their more idealised contemporaries. For those wishing to read more, there is a modern edition of his book, edited by Adam Sowan.

Isaacs, Rufus, 1st Marquis of Reading

In the communal gardens of Eldon Square, off London Road, stands a statue of one of the most distinguished statesmen to be associated with Reading. It was presented to his widow by the Government of India after independence, and she arranged for it to be displayed in the town. In his time, Rufus Isaacs was a lawyer, Liberal Member of Parliament for Reading (1904–13), Solicitor General for England (1910), Lord Chief Justice of England (1913–21), Ambassador to the United States (1918–19), Viceroy and Governor-General of India (1921–26), and Secretary of State for Foreign Affairs and Leader of the House of Lords (1931). He was made Marquis Reading in 1926, the highest rank in the peerage ever attained by a Jew.

He was born in 1860 in Spitalfields, London, the son of a fruit merchant, and entered the family business aged fifteen. After spells as a ship's boy and a stock exchange jobber, he studied law and was called to the Bar in 1887. By 1898 he had become a Queen's Counsel. 1904 saw him elected MP for Reading and he came to live at Foxhill, a house originally built by the distinguished architect Alfred Waterhouse for his own use (now part of the university's Whiteknights campus).

One blot on his career was the Marconi affair of 1913, in which he was one of a number of senior politicians accused of insider dealing, by acquiring a number of Marconi shares shortly before the company was awarded a government contract. The matter was investigated by a parliamentary select committee, but while their fellow Liberal members of that committee cleared them of any criminal wrongdoing, opposition members condemned them for 'grave impropriety'.

In his career Isaacs championed a number of progressive measures, such as the taxation of land values, reforms in the legal standing of trades unions and a national social insurance scheme. By the time of his death in 1935 plain old Rufus Isaacs had become the Most Hon. Marquis of Reading GCB, GCSI, GCIE, GCVO, PC, KC.

Isaacs' first wife, Alice, died in 1930. His second, Stella (1894–1971), had a formidable career in public service in her own right. She was known as Lady Reading, rather than the Marchioness and, among her many activities, she served on the BBC Advisory Board and was Vice-Chair of its Board of Governors, helped found the University of Sussex, chaired a Home Office Council on Commonwealth Immigration, but was best

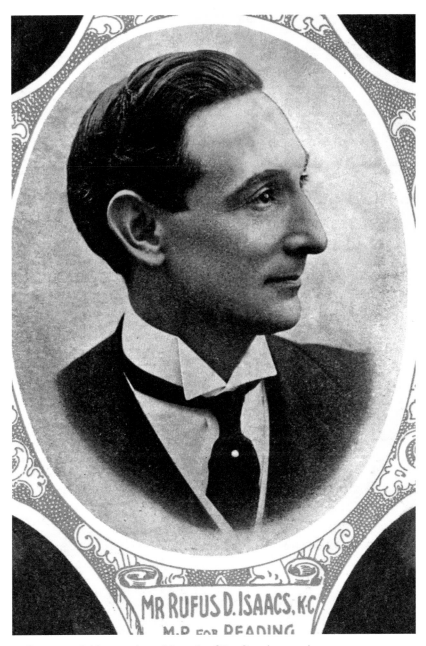

Rufus Isaacs (1860–1935), 1st Marquis of Reading (1310993).

known for founding the Women's Voluntary Service (the WVS). Her many honorary degrees included one from the University of Reading (1947). She was created a Life Peer in her own right in 1958 and was the first woman to take her seat in the House of Lords. It was said of her (in pre-Thatcher days) that, with her political talent and strength of character, she could have been prime minister – had she been a man.

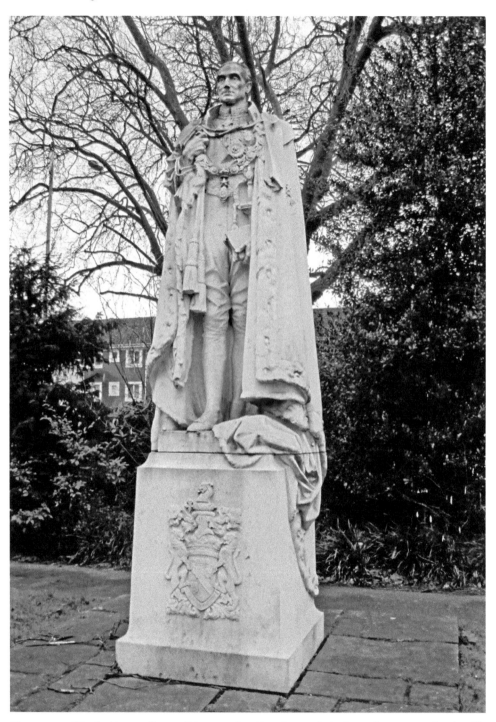

The statue of Rufus Isaacs, former Viceroy of India. The newly independent state of India felt no need to retain this symbol of imperialism and returned the statue to Isaacs' widow. It now stands in the gardens at Eldon Square.

J

Justice – Crime and Punishment in Reading

Lawbreakers in Reading over the years could be subjected to a variety of sentences, many of which seem brutal and sadistic to modern eyes.

For many years, until 1793, the town's main prison was a set of subterranean cells on Castle Street. The gaoler looked to supplement her (in 1793 the jailer was a widow) meagre living from them by charging the inmates for all but the most basic necessities of life. (Among other things, she was licensed to sell them beer and wine.) Those prisoners without private means were reduced to begging to passers-by through a grating in the pavement. Into these overcrowded and squalid conditions were crammed felons, debtors, religious Dissenters and press-ganged men on their way to the navy.

This squalor was at least matched by the town's bridewell or house of correction. From 1631 this was located in the ruined and partly roofless remains of Greyfriars Church. The side aisles of the church were partitioned off into windowless, airless cells, measuring around 14 feet by 6 feet, each containing up to six prisoners. The prisoners had no light, no heating, slept on straw and lived on bread and water. They had the added amenity of an earth privy, an open cesspool and wall-to-wall rats. As one contemporary observer put it, 'The ingenuity of man, one would have supposed, could not have contrived a place so well adapted to reduce their fellow men below the condition of beasts.'

Torture was not unknown to extract a confession from a suspect. The record of burials at St Mary's for 7 July 1585 includes one John Greenwoode, who suffered *peine forte et dure*, or being pressed to death. This involved the prisoner being given the choice of confessing to their alleged crimes, or of having ever heavier weights piled on them, until they were fatally crushed.

John Nixon's book *The Gentlemen Danes* includes an eye-witness account of a man being pilloried in Reading in the summer of 1811. This pillory took the form of an elevated rotating device, into which the criminal was locked by his head and hands. As the pillory was rotated:

The rabble threw filth from the gutter, rotten eggs and apples, animal intestines and other foul things at his head, and potatoes and cabbages at his body. It did not last long before, instead of a face and head, one could only see a mass of muck and filth, and still the criminal grinned with an evil brutish grin at the screaming mob, when he was allowed at intervals to scrape the muck off so that his eyes and mouth became free.

Corporal punishment could even turn into capital punishment. The pillory could be fatal, depending upon what was thrown, and in 1816 an unemployed workman living in a slum in Silver Street was caught stealing a loaf of bread. He was sentenced to be whipped, was stripped to the waist and tied to the tail of a cart. While the cart made its way from the bridewell to the prisoner's home, the keeper of the bridewell, a man named Paradise, carried out the sentence with extreme brutality. Not an inch of the man's back was left unshredded by the time they reached the victim's home, and he died without ever leaving his home again.

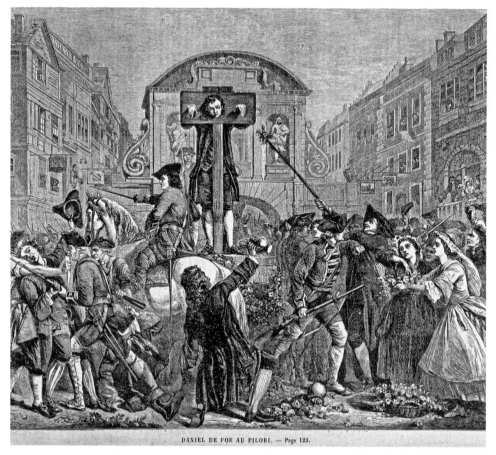

DANIEL DE FOE AU PILORI. — Page 123.

The author Daniel Defoe receiving rough justice in the pillory (Wikimedia Commons).

K

Kennet & Avon Canal

In ancient times Reading was chosen as a place for a settlement partly because it was at the junction of the rivers Thames and Kennet. From its earliest days, waterborne transport was vital to the local economy. Reading was about as far up the Kennet as most boats could navigate, and trade was drawn into the town from a wide catchment area for that reason.

Townspeople were therefore naturally worried when, in 1715, the Kennet Navigation Act was passed, allowing the Kennet to be made navigable as far west as Newbury. This led to violence in 1720, when a mob of some 300 citizens, led by the mayor, Robert Blake, attempted to destroy part of the canal workings. (Incidentally, Blake's Lock on the Reading stretch of the Kennet is not satirically named after its would-be saboteur Robert Blake, but apparently after a John Blake, who owned a wharf on the Kennet in around 1650.)

The canal opened in 1723, but only after the incompetent first engineer had been sacked and his successor put in 11½ miles of cuttings to shorten the distance between Reading and Newbury to 18½ miles. Local opposition to the canal then turned from vandalism to stoning passing bargees and issuing them with blood-curdling death threats. But the new canal led to a period of renewed prosperity for Reading, and gave rise to thoughts of a grander project.

There had been talk of linking London and Bristol via the Thames, Kennet and Avon since the reign of Elizabeth I – at one point along their routes, the Kennet and Avon were only separated by 3 miles of relatively flat ground. In 1794, the construction of the Kennet & Avon Canal received parliamentary approval and, under the supervision of the engineer John Rennie, was completed in 1810. It gave Reading access not just to Bristol, but also to a canal network serving many parts of the country. The town's produce found major new markets and everything from coal and agricultural produce to manufactured goods could now be had more easily and more cheaply in Reading. By 1835 some 50,000 tons of goods a year were going into, or out of, Reading by canal.

But the coming of the railway to Reading in 1840 marked the beginning of the end of the canal era. The Kennet and Avon went into a long period of decline, which was not helped by the Great Western Railway taking it over, in order to allow it to

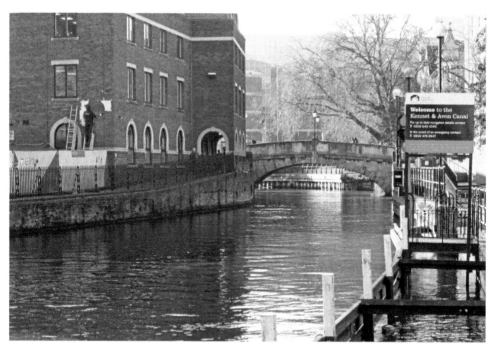

The Kennet & Avon Canal and the High Bridge. The High Bridge was designed by architect Robert Brettingham and is a scheduled Ancient Monument. This part of the canal is an unusual stretch of waterway, controlled as it is by traffic lights.

Blake's Lock at the eastern end of the Kennet & Avon Canal. This was the subject of a riot in which the citizens of Reading (led by their mayor, Robert Blake) tried to destroy the lockworks.

The Horseshoe
Bridge, a listed
structure originally
used to carry
canal barge horses
across the opening
of the Kennet &
Avon Canal,
where it joins the
Thames.

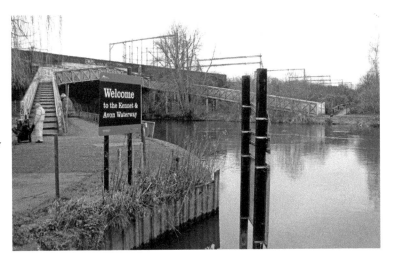

This office building, the Jolly Green Giant, now stands on the waterfront land once occupied by the medieval abbey wharf.

decline, in 1852. A century later and it was virtually unnavigable. Right up until the 1950s the canal's supporters saw it predominantly as a corridor for business traffic. It took the discovery of a new leisure role for the canal and a lot of determined work (and lobbying) by an army of volunteers to bring about its reopening in 1990.

Law and Order – the Early Reading Police Force

Before Reading had a police force, it had nightwatchmen. They patrolled the streets by night, shouting out the time and the weather, and were also supposed to apprehend villains. But they were often as not drunk and had a tendency to vanish at the first sign of trouble.

One of the first actions of the newly reformed Reading Corporation after 1834 was to set up a professional police force, which they did by 1836. It was one of the first provincial towns to do so – London, the first to do so, only got its Metropolitan force in 1829. Reading's initial force consisted of thirty constables, two sergeants and two inspectors – or one officer for every 600 or so inhabitants. Many of them were former military men. They were strictly beat officers, following a closely prescribed route and reporting in regularly, and not encouraged to take initiatives such as pursuing fleeing criminals or solving crimes.

Their initial headquarters was at No. 6 Friar Street, near St Laurence's Church, the home of the former nightwatchmen, and their lock-up was in the roofless remains of the former Greyfriars church. Not until 1862 did they get a new police station and coroner's court building at High Bridge House, London Street.

Gradually the force acquired the trappings of modern policing. The first evidence of plain clothes activity came in 1857, when they paid out £2.45 for a plain suit for a detective constable. The Chief Constable got a telephone in 1897, fingerprinting started being used in 1901, photographing prisoners in 1906 and in 1904 they even acquired a typewriter. As criminals got more mobile, the force responded in 1924 by acquiring a 12 horsepower Austin saloon, though this was mainly used to ferry the Chief Constable to formal engagements. Radio communications for beat officers were still some way off, but 1928 saw the introduction of the first police telephone box (an idea familiar to fans of *Dr Who*). It stood on the southern side of Caversham Bridge and gave patrolling officers a direct line to police headquarters.

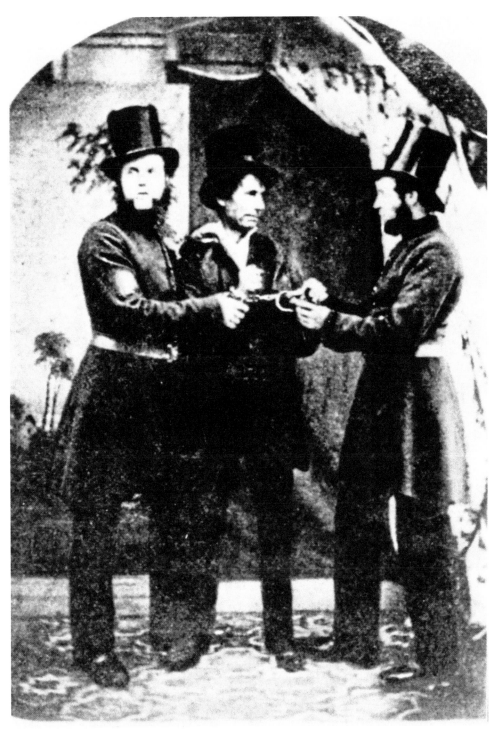

An early staged photograph showing two policemen 'detaining' a villain in around 1860. The officers are actually from the next-door Wokingham Division (1173052).

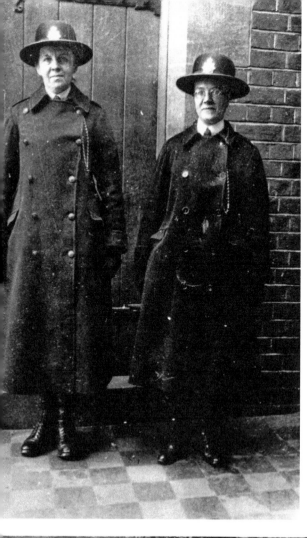

Left: Miss Campbell and Miss King, two of Reading's early police officers. Reading had females on the force from 1917, but not until 1941 were any sworn in as actual constables (1267696).

Below: September 1930 and Sir Leonard Dunning, the Home Office's Inspector of Constabulary, casts an eye over Reading's flying squad of four motorcycles (1267717).

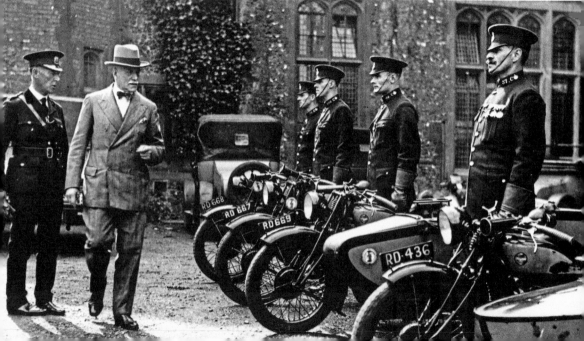

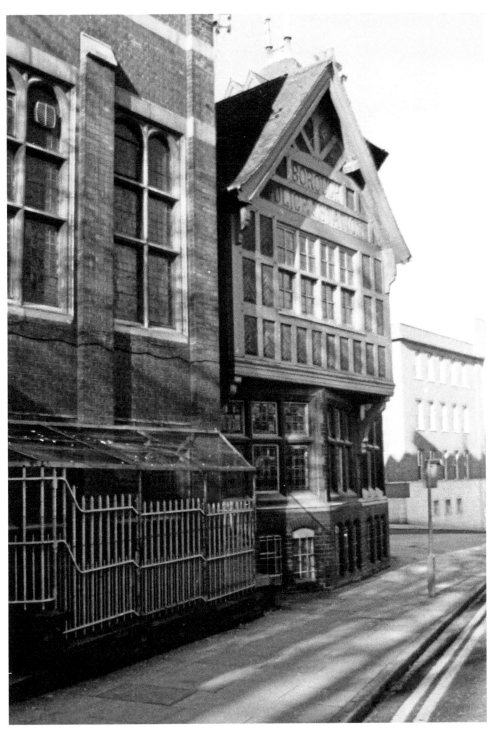

In 1912 the police took over the former University Extension College premises in Valpy Street as their new headquarters (1269691).

The building next to the High Bridge on the River Kennet was the police force's new headquarters and coroner's court from 1862. It is now used as offices. Appropriately for its canal side location, this listed building is in the Venetian Gothic style.

The Reading Police were given a wide variety of roles over the years. Up to 1893 the Superintendent of Police was also responsible for managing the fire service, and before 1862 police officers were even expected to man the town's fire appliances. They had responsibility for directing the traffic in the days before traffic lights sprung up at every junction. They exercised the censorship laws on the films shown in the town's cinemas, dealt with alien registration, lost property, firearms and, in 1909, were even called upon to act against a Catholic church congregation, apparently guilty under some archaic law of parading in the streets in their Popish robes.

As the world – and in particular, crime – got more complex, small local police forces were no longer equipped to deal with it. In 1968, Reading Borough Police merged with a number of other forces to form the Thames Valley Police.

M

Ian Mikardo MP (1908–93)

When Moshe Mikardo, a Russian Jewish tailor, landed in Britain after the Jewish pogroms of 1903, he possessed little more than the clothes he stood up in, spoke not a word of English and could not read or write in any language. But his son Ian was to become a long-serving, senior and controversial Member of Parliament. He represented Reading (or part of it – the boundaries changed) from 1945 to 1959.

His political career was confrontational from the start. At the 1944 Labour Party conference, a young Mikardo forced through a left-wing motion that senior Labour figure Herbert Morrison told him would lose Labour the General Election. But come 1945, both Labour and Mikardo were successful at the polls.

Mikardo was an influential figure in the national Labour Party and its policy over many years but, at a local level, the press accounts concentrate on his role as a controversialist. His relationship with the local press in Reading started out badly and got steadily worse. In the 1950 election they sent their fashion, rather than political, correspondent to cover his meetings, who reported only the details of his attire rather than his policies (and even got that wrong). The paper made no attempt at impartiality, casting his Conservative opponent in near-saintly terms, while Mikardo was portrayed as a hypocrite who ran down capitalism while making a good living from it. A victorious Mikardo enjoyed a bit of sarcasm at the paper's expense, thanking the 'old man' who wrote the paper's editorials for driving so many voters into the Labour camp.

Having won the election, Mikardo still antagonised part of the electorate, characterising working-class Conservative voters as snobs; and when the local council declined to give enthusiastic support to the Festival of Britain, Mikardo criticised their 'sickening hypocrisy'. Meanwhile, his speeches in Parliament led to a Press Council complaint from a fellow Member, and to Mikardo being forced to make a public apology in the Commons.

Uncharacteristically, he spoke out strongly in favour of the royal family receiving payments from the Civil List. This mainly speaks volumes about the high esteem in which the royal family was held in the 1950s. But by 1956 he was back on form, singing the praises of Russia and China for their achievements in education and

town planning. His enemies on the local paper expressed the wish that he would stay there long term and study these matters in far greater depth. It also emerged that Mikardo's speeches as an active Zionist had led to his own party having his phone tapped. On finding this out, he warned that 'we are fast on the way to 1984'. He also condemned the Street Offences Bill, designed to sweep prostitution off the streets, citing his specialist knowledge of how New York call girls organise things, and likened Prime Minister Harold Macmillan to Archie Andrews (a popular ventriloquist's dummy of the day).

Come the 1959 General Election and Mikardo's wafer-thin majority made him a prime Conservative target. The campaign got predictably tetchy, with Mikardo accusing the Conservative candidate of falsifying job vacancies and the Conservatives complaining about mudslinging. The election produced a Conservative majority of 3,942 in Reading. The local press were almost pleasant to him in his moment of defeat, acknowledging that he was never dull, and ending with the words of the First World War song 'we don't want to lose you, but we think you ought to go'.

For his part, Mikardo's parliamentary career continued in London constituencies from 1964 until 1987. His memory is commemorated locally in Ian Mikardo Way, a street in Lower Caversham.

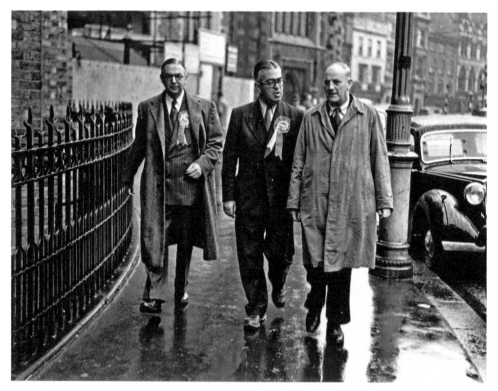

Ian Mikardo (centre) seen during the 1951 election campaign with R. W. G. Mackay, candidate for the other Reading seat, and Mr Grierson, the Labour Party's local agent (1302652).

Newspapers

Before 1723, anybody in Reading who wanted to read a newspaper had to rely on one from London. By the time they reached Reading the news in them was stale and there was little or no local content. They were also expensive, with stamp duty and newsprint costs making up over half the 7*d* (3 new pence) cost of a paper (excluding postal costs).

That year saw the emergence of Reading's first newspaper, the *Reading Mercury* or *Weekly Entertainer.* It got around the payment of stamp duty by classifying itself as a pamphlet (a loophole that the government rapidly closed). To call it a Reading newspaper is something of a misnomer, since it circulated over a much wider area and consisted almost entirely of national or international news, lifted from the London papers. This could cause confusion, as when they published a table of mortality, recording deaths by different causes. This showed forty-two deaths that week from smallpox alone, which alarmed a town whose total population was no more than 8–9,000. It turned out that the figures were for London, not Reading.

The paper's initial circulation was small – around 400, only rising to 1,000 by 1800 and 4,000 by 1855. Little attempt seems to have been made to gather any local news. The 1841 census records only one journalist in the whole of Berkshire. Such local news as they printed was generally supplied by readers (and not always thoroughly checked by the newspaper). At least one reader had the dubious pleasure of reading his own obituary. The paper was not even successful when it tried to run a spoof. When the Reading Paving Act was making its way into law, it contained a clause requiring all horses in the borough to be muzzled. The *Mercury* ran a supposedly funny story that Mr Cocks (see under section S for sauce) had been prosecuted for allowing a wild creature, to wit a turtle, to be at large unmuzzled, contrary to the provisions of the Act. Many readers took it seriously.

The *Reading Chronicle* (originally the *Berkshire Chronicle*) was a relative newcomer. Its links to another *Berkshire Chronicle*, first published in Wokingham in 1770, are tenuous, and a more realistic starting date for it is 1825. Almost immediately the two newspapers were at each other's throats, in a welter of abuse and libel actions (actual or threatened). They took opposing sides over issues of the day, such as the building of

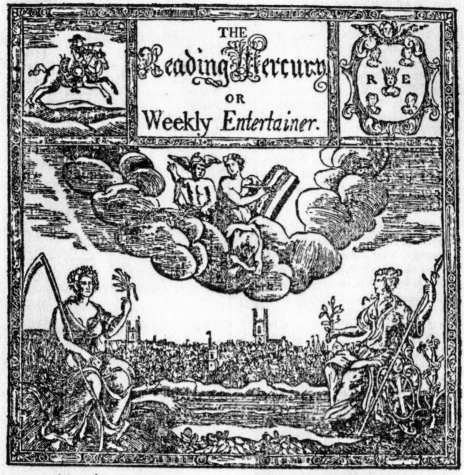

The front page of the first edition of Reading's first newspaper, the *Reading Mercury or Weekly Entertainer* of 8 July 1723.

The old *Berkshire* (later *Reading*) *Chronicle* building in Valpy Street.

the railway through Reading or the Reform Bill, and public figures who sided with one or the other publication could look forward to fawning adulation or the blackening of their character, depending on which paper they read.

More recently, the *Chronicle* was mired in controversy in 2014 when it published a piece on hooliganism at Reading Football Club. Among other things, it implied a link between hooliganism and the 1989 Hillsborough disaster, and a furious football club forced them into making a front page retraction and apology.

A further local paper – the *Reading Standard* – appeared in 1891. This was taken over by the Thompson organisation in 1965, and was replaced by the *Reading Evening Post* – the first daily evening newspaper to be published since the Second World War, and one which now exists only in electronic form.

Back numbers of the local newspapers are held on microfilm at Reading Central Library.

O

The Oracle – a Tale of Mismanagement

Before the libel lawyers start circling, this piece is not about today's retail complex, but its predecessor of the same name.

John Kendrick was a Reading man who made his fortune in the clothing industry in London. In his will of 1624 he left £7,500 to the Corporation of Reading. They were to use it to purchase 'a fair plot of ground within the town of Reading' and to build on it 'a strong house of brick, fit for setting the poor to work therein, with a garden adjoining'. They were also to maintain 'a common stock, to be employed and bestowed in trades of clothing, and also of working in stuffs for dyeing, or otherwise'. In the event that the trust was not managed in accordance with Kendrick's wishes, the property was to pass to the Mayor, Commonality and Citizens of London, for the benefit of Christ's Hospital.

Generous and well-intentioned though this bequest was, its timing was most unfortunate. Cloth and clothing had been the town's staple industries for centuries, but they were now in decline. The Civil War, and Reading's long siege, would soon run the local industry into the ground. Worse, it soon became clear that a small clique of the town's clothiers – members or friends of the Corporation – had diverted part of the Kendrick bequest to support their own businesses and undercut the competition. Far from rejuvenating the local industry, they were putting people out of work.

By 1639 complaints about this reached the ears of the Attorney General. The Archbishop of Canterbury at this time was the Reading-born William Laud, and he intervened to make the Corporation buy land with part of the bequest. The income from this was to be put to charitable use. Meanwhile, various small businesses were being run from the Oracle – though not necessarily the ones Kendrick had specified. After the Civil War part of it was turned over to housing the poor, rent-free, their subsistence paid for by the parish. This led to complaints that their children were being raised in idleness, not industry. Complaints were also made that the inmates of the Oracle were being locked in there, 'to prevent the poor from begging about the streets and being disordered in liquor', and that parts of the building were being let out illegally to third parties.

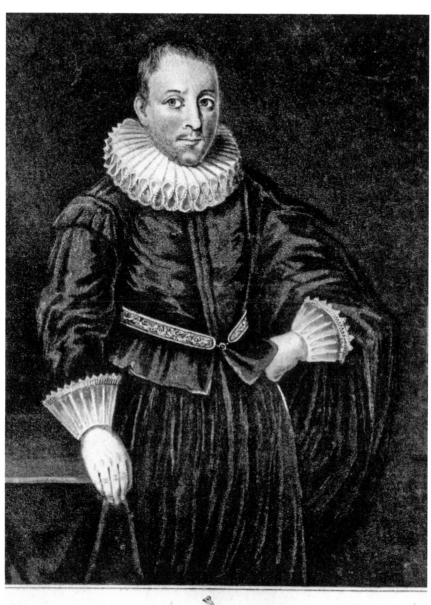

John Kendrick (1574–1624), the Reading-born man who funded the building of Reading's original Oracle (1291601).

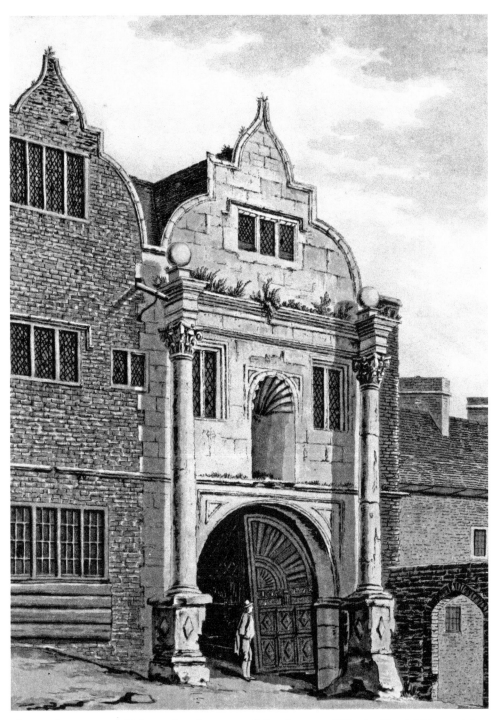

The Oracle entrance, which stood at the corner of Gun Street and Minster Street. This was taken from an 1802 engraving by Charles Tomkins, which appeared in *The History and Antiquaries of Reading*. The niche above the entrance was supposed to have held a statue of its founder (1323863).

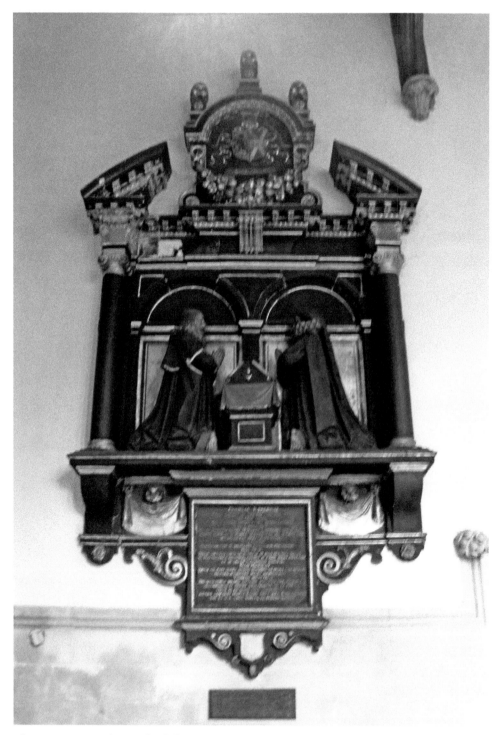

The monument to the Kendrick family, the founders of the original Oracle. The monument can be seen in St Mary's Minster Church.

Repeated attempts were made over many years to invoke the default clause in Kendrick's will, given the clear evidence of mismanagement. But it was not until 1849 that the governors of Christ's Hospital made a successful claim against the Corporation. By this time, the building was a semi-derelict home to petty criminals. Part of the assets of the Kendrick bequest went to found the Kendrick schools in Reading, but the majority of it passed to Christ's Hospital. The building itself survived demolition just long enough to be captured by the pioneer of modern photography, William Henry Fox Talbot.

Reading and the Postal Service

In the days before the railways, the fastest way for Reading people to travel round the country was with the mail. During the reign of the Elizabeth I the government set up a network of coach routes. At first they were mainly for the delivery of government mail, but they also carried a certain number of private letters. One of these routes, founded in 1579, ran between London and Ireland and passed through Reading. Charles I saw the money-making potential of the service and in 1635 threw it open to all private mail, as a means of cross-subsidising the government part of the service.

A man named Richard Spignall was made postmaster for the Reading part of the route. His main task was supplying the horses needed for that stage of the journey and generally expediting the coaches. These duties fitted in well with those of an innkeeper. Many of the early postmasters were also pub landlords, and their pubs became (officially or unofficially) sub-post offices. Prior to 1895 the building that stands at the junction of Broad Street and Chain Street apparently combined the roles of alehouse and post office, being known as the Post Office Tavern.

From the 1780s private letters arriving in Reading would be delivered at no charge within a small area around the post office. Anyone living further afield was expected to collect the letter from the post office themselves (though how they were supposed to know they had a letter awaiting collection is not entirely clear). But enterprising postmasters saw a way of augmenting their income, by charging extra for delivering letters to farther-flung destinations. (At that time it was common practice for the cost of a letter to be borne by the recipient. It was one way of ensuring that the mail actually got delivered, since not all the early post office staff were scrupulous in performing their duties.) Local carriers could be hired to deliver mail to convenient locations in outlying villages (the village pub was, again, apparently a favourite venue). The carriers would style themselves as postmen and a blind eye was turned to their illegal enterprise. The town's tram service later operated something similar, providing a parcel delivery service around the town.

Theft from the early postal coaches was a real possibility. The stretch of road between Maidenhead Thicket and Reading was particularly notorious for highwaymen. Some

people even advised sending banknotes and other valuable documents in two halves, by separate services. The operators responded by installing armed guards on the coaches, but they were almost as much of a nuisance as the criminals, discharging their blunderbusses at any wild or domesticated animal that took their fancy and terrifying the locals. On two occasions their 'bag' included a turnpike toll collector and a would-be passenger who was trying to flag the coach down to board it.

Until the 1830s, letters posted at 9.00 p.m. on Monday would still not reach London until 7.00 a.m. Tuesday, while those to Birmingham took until 9.00 a.m. on Wednesday to arrive. This would all change from May 1840, when the London mails from Reading started to be carried by railway. January 1841 saw the introduction of the national penny post and the monthly average number of letters delivered in Reading soared from around 3,800 to 10,000. A larger main post office was established in Broad Street, with sub-offices in the south and the east of the town and, in 1844, the town's postmen were given a uniform, paid for by public subscription.

Until the coming of the railways, the mail coaches passing through Reading were the fastest means of travelling around England. This was how they looked in around 1840, just as they were being superseded (Wikimedia Commons).

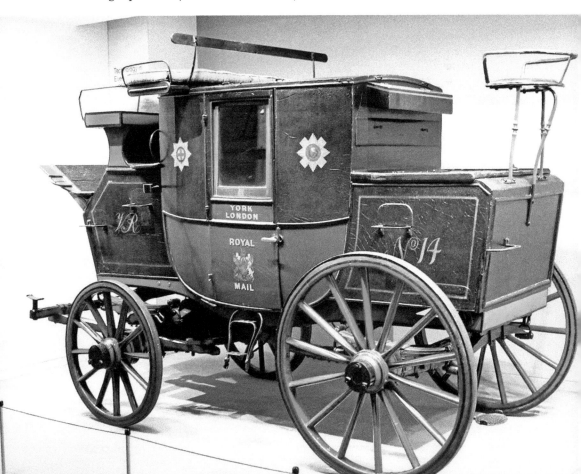

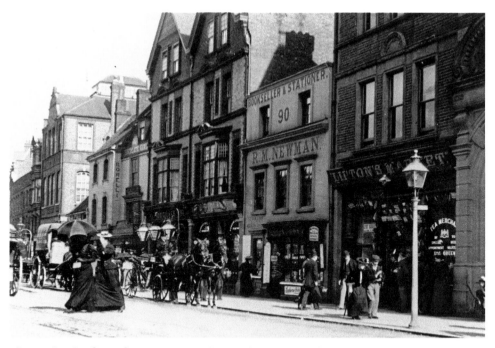

The south side of Broad Street in around 1896, showing one of the sites of the town's post office (1187913).

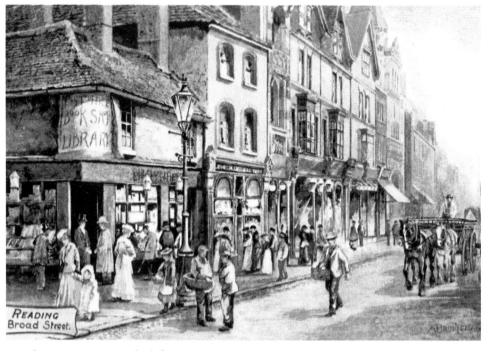

Broad Street, *c.* 1900. On the left is G. A. Poynder's bookshop, library and sometime post office (1191717).

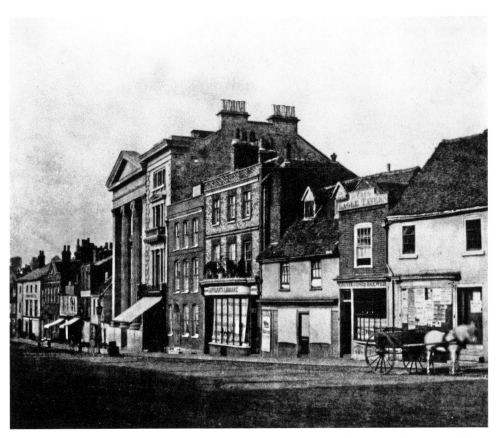

A photograph by the pioneer photographer Fox-Talbot, dating from around 1845. It shows London Street, including Lovejoy's shop, which at one time also served as a post office (1217224).

Queens Road (and Kings Road)

On the earliest surviving map of Reading (John Speed, 1611) there is no Queens Road (or its counterpart, Kings Road). All the area to the east of London Street appears to have been in agricultural use, and may have been part of the property known as Orts Farm. However, there is a lot of archaeological evidence of settlement in the general area, going right back to Palaeolithic (early Stone Age) times, with finds also dating from the Neolithic period, the Bronze and Iron Ages, to the Saxons and beyond. The area is thought to have been part of that occupied by the invading Danish army in AD 871. The stables to Reading Abbey are believed at one time to have stood on or near the site now occupied by the Central Library, and the nearby Abbey Wharf (just north of modern-day King Street) was an important focal point for the trade of the mediaeval town.

Commercial use of the River Kennet upstream of central Reading was difficult until the river was made navigable as far as Newbury in 1724. But the real impetus for development of the Kings Road/Queens Road area came with the opening of the Kennet & Avon Canal through to Bath and Bristol in 1810 and the building of a new wharf and dock in the town in 1828. The land on which the two roads now stand was owned by the Crown and it was their Commissioners of Woods and Forests that put it up for sale in 1832/3.

The king and queen in the road names were William IV and Queen Adelaide. Adelaide (1792–1849) was a German-born member of a minor royal family. She was twenty-seven years younger than William when they married in 1818 and was said to have been a positive influence on the king, making him less drunken, foul-mouthed and tactless when in her presence. William succeeded to the throne in 1830 on the death of his brother, George IV. William IV himself died in 1837 and none of his and Adelaide's children survived childhood. Had they done so, we might never have had a Queen Victoria.

The two roads were built at the same time as each other, Queen's Road being an initiative of the Corporation of Reading 'under the superintendence of the late Mr. J. J. Cooper, Architect and Surveyor' as William Darter, the town's mayor and one of its historians was later to recall. Darter's memoirs (*Reminiscences of Reading by*

an *Octogenarian* (1888)), give an anecdotal pen picture of the people living in this area at the time. One, a parish clerk named Mr Elkins, was unexpectedly aroused at night by one of his servants and immediately died of apoplexy.

Before Queens Road was built, access to it was blocked by three old houses on London Street, occupied by a silk manufacturer, a butcher and a blacksmith, which had to be demolished. In the case of Kings Road, at its western end what is now King Street was divided by a row of old properties into Sun Lane and Back Lane. A prosperous draper named Alderman Richards bought them up and demolished them, creating the spacious King Street we know today and opening the way for King's Road to continue eastwards.

Queen Adelaide is also commemorated in Adelaide Road, near the university, as is the wife of Edward VII in Alexandra Road.

In more recent years the Queens Road became famous (or possibly infamous) for the Queens Road Alternative. This was a highway scheme dreamed up in 1977 by Berkshire County Council to replace the hideous environmental vandalism of their original Inner Distribution Road proposals. It would have been less environmentally damaging (and considerably cheaper) than the scheme it replaced, but even this proved too much for the cash-strapped highway authority and it was abandoned by 1980.

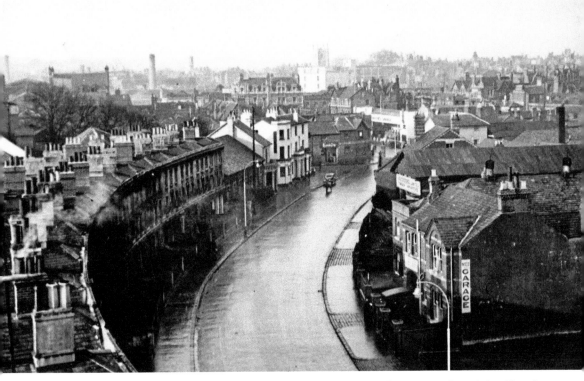

Queens Road, *c.* 1935, showing the view to the west from high up on Holy Trinity Church (1223292).

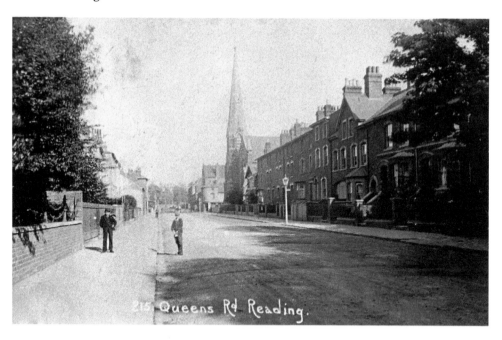

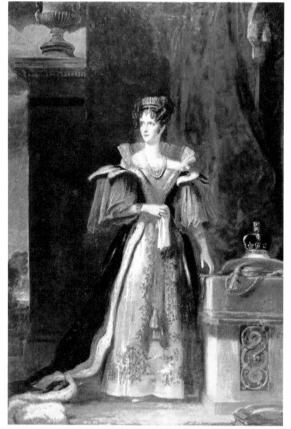

Above: Queens Road, looking east in around 1910. The Wesley Methodist Church and Watlington Street can be seen on the right (1248234).

Left: Queen Adelaide, after whom Reading's Queens Road was named (Wikipedia).

One of the few remaining historic parts of Queens Road, the listed Queens Crescent, was built in around 1832/3, when the road was first commissioned. Today it stands in an environment dominated by traffic.

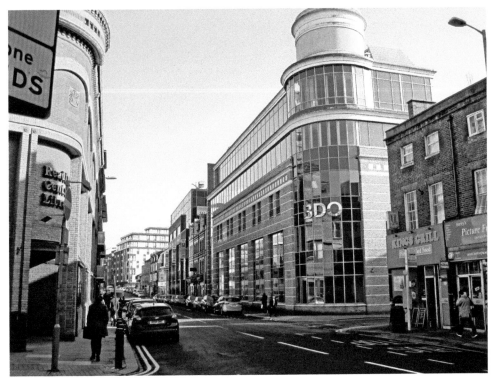

The modern Kings Road, mostly offices and executive apartments.

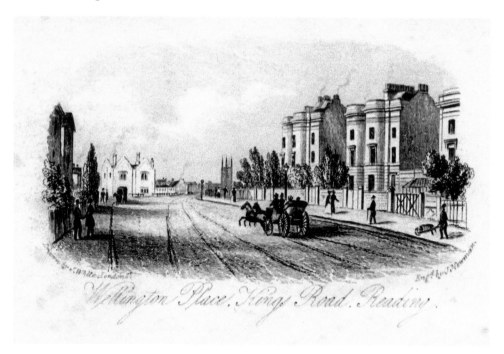

Kings Road looking west in around 1840. The view is from Wellington Place (which is what the buildings on the north side of Kings Road used to be called), and St Laurence's Church can be seen in the background.

R

Royal Berkshire Regiment, Brock Barracks and Sherlock Holmes

Anyone going westwards along the Oxford Road cannot help but notice an imposing fortress-like structure. This is Brock Barracks, but what was it for and who or what was Brock?

Brock Barracks takes its name from Major-General Sir Isaac Brock (1769–1812), a distinguished soldier, but one with little immediately obvious connection with Reading. He was born in Guernsey and served the key part of his military career in Canada, where he earned the soubriquet 'The hero of Upper Canada' for his defence of that area against the incursions of the United States. He died at the Battle of Queenston Heights. The Berkshire link was that part of what would eventually become the Royal Berkshire Regiment (the 49th Regiment) was under Brock's command from 1791.

The barracks themselves were completed long afterwards, in 1881, and are built in what is called the Fortress Gothic Revival style. They were part of the Cardwell reforms, carried out by the Liberal government of the 1870s to address the growing military threat of Prussia and the shortcomings of the British Army, thrown into sharp relief by the Crimean War. It initially became the depot for the 49th (Hertfordshire) Regiment of Foot and the 66th (Berkshire) Regiment of Foot. The two regiments were merged to form the 1st and 2nd Battalions of the Berkshire Regiment later in 1881.

This was after the 66th had had their moment of glory (that is to say, were massacred) in the Second Afghan War in 1880. They were the rearguard, covering the retreat of the rest of the British forces, when they came upon an Afghan force outnumbering them ten to one, and armed with the latest (British-made) artillery. Their heroic rearguard action enabled the rest of the force to escape, but at a cost of 286 Berkshires killed and another thirty-two wounded. The Battle of Maiwand is commemorated by the lion statue in the Forbury Gardens.

Doctor Watson, Sherlock Holmes' partner, was modelled on the Royal Berkshire's Chief Medical Officer, Surgeon-Major Alexander Francis Preston. He fought, and was badly wounded at, the Battle of Maiwand. He was invalided home and lived on

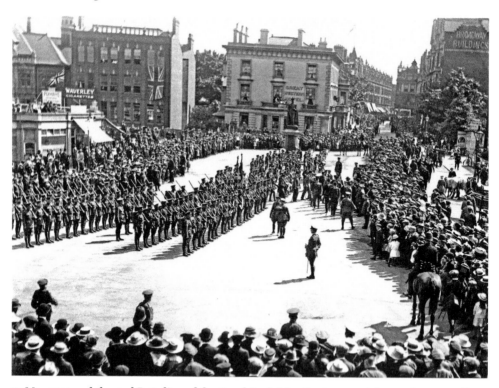

17 May 1919 and the 2nd Battalion of the Royal Berkshire Regiment celebrates its return from the First World War outside Reading railway station (1302605).

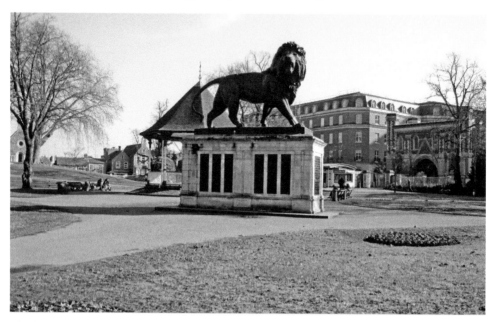

The lion in Forbury Gardens, commemorating the heroic last stand of the Royal Berkshire Regiment at the Battle of Maiwand in 1880, during the Afghan Wars.

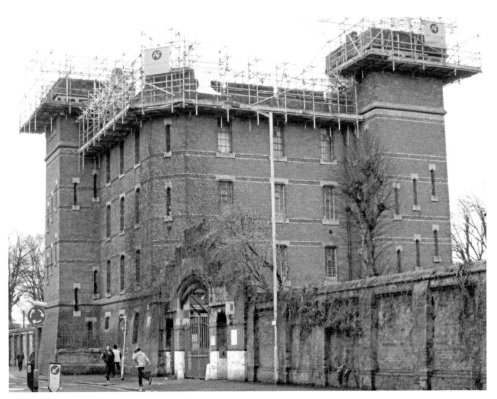

Brock Barracks on the Oxford Road, built in 1881 as a headquarters for the Royal Berkshire Regiment.

Tofrek Terrace, named as a reminder of the part the Royal Berkshires played in the Afghan Wars of 1880–81. The Battle of Tofrek lasted just twenty-five minutes and resulted in a heavy defeat for the Mahdists, in which the Berkshires played a key part. From this they earned the 'Royal' part of their regimental name.

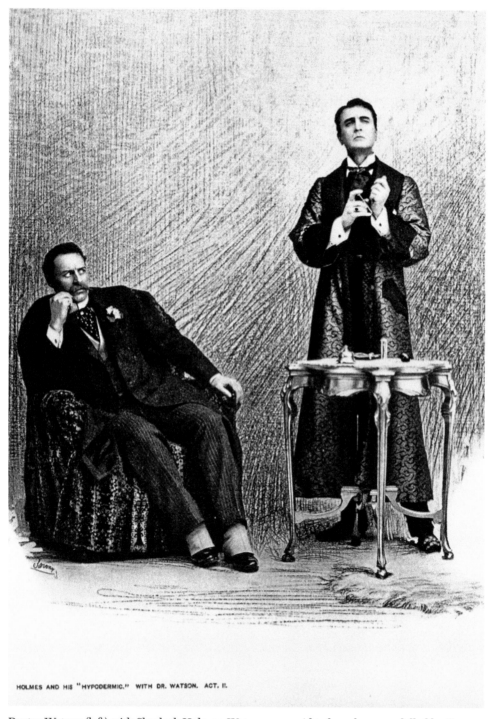

HOLMES AND HIS "HYPODERMIC." WITH DR. WATSON. ACT. II.

Doctor Watson (left) with Sherlock Holmes. Watson was said to have been modelled by Conan-Doyle on Francis Preston, the chief medical officer of the Royal Berkshires, who was wounded at the Battle of Maiwand (Wikipedia).

until 1909. His real-life CV closely paralleled Watson's fictitious one, including the Battle of Maiwand.

Where does the 'Royal' in the Regiment's name come from? The 49th had royal associations since 1816, when they were guarding the royal family at Weymouth. The young Princess Charlotte of Wales was so impressed with their smart uniforms that she asked for them to be made 'her' regiment. But the 'Princess Charlotte of Wales' Regiment' only became the Royal Berkshire Regiment in recognition of their part in the Sudan campaign of 1885, including their role in the Battle of Tofrek (which explains why the adjoining street to Brock Barracks is called Tofrek Terrace).

During the Second World War the 401st Glider Infantry Regiment of the 101st Airborne of the United States Army were based in Brock Barracks as they prepared for the Normandy landings. As for the Royal Berkshire Regiment, it merged with the Wiltshire Regiment to become the Duke of Edinburgh's Royal Regiment, based on the Isle of Wight, in 1959. Their administrative headquarters left Reading for Salisbury in 1982. The barracks have since been used as a Territorial Army base.

There are various published histories of the Royal Berkshire Regiment, including those by Colin Fox, Martin McIntyre and Frederick Myatt.

Sauce

Victorian Reading was famed for its three B's – beer, biscuits and bulbs – but for more than a century it was equally well known for Cocks' Reading Sauce. For over a century it rivalled the Worcestershire variety in popularity.

James Cocks opened a fishmongers shop in 1789. It was originally located in Bucher Rowe, one of the two narrow lanes into which what is now the eastern end of Broad Street was then divided. By 1793 he moved to Duke Street. Originally he sold someone else's brand of fish sauce but by 1802 he and his wife Anne had devised and started to market their own recipe. It rapidly became a success, to the extent that his advertising claimed by 1811 that it had 'for many years been patronised and recommended by most of the first families of the kingdom'. From 1851 it was also exported to India.

It was also widely counterfeited, and an advertisement in *The Times* on 16 August 1816 warned the public against 'the daily frauds and impositions practiced by many London oilmen and fish sauce vendors to deceive and deprive them of the genuine Reading Sauce'. Cocks even went so far as to put an additional label on his bottles, recording two prosecutions of counterfeiters within the last twelve months, for Cocks was assiduous in hunting down imitators.

Secret recipe or not, we have a pretty good idea of what went into it, and it must have been a pretty robust product (ideal for disguising slightly off fish in pre-refrigeration days). Ingredients included walnut ketchup, mushroom ketchup, soy sauce, anchovies, chillies, garlic, vinegar, 'much cayenne and salt' and shallots. Mrs Beaton even produced her own recipe for a version of it, which took three hours to prepare and left you with half a gallon of the stuff.

James died in 1827 and son Charles took over the business. He opened a bigger factory on the King's Road (on the site where Reading's Central Library now stands) and continued his father's pursuit of counterfeiters. The sauce was one of the exhibits at the Great Exhibition in 1851, but perhaps the high point of the product's fame came in 1872, when it featured in Jules Verne's book *Around the World in Eighty Days*. In it, the hero of the story, Phileas Fogg, dines at the Reform Club on 'broiled fish with Reading Sauce'. If this literary fame were not enough, Lewis Carroll wrote a decidedly unmemorable couplet featuring the product. Their King's Road factory was developed

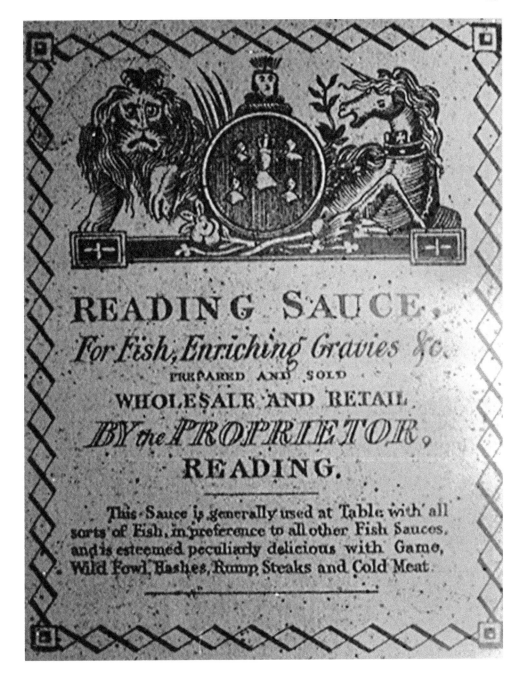

READING SAUCE,

For Fish, Enriching Gravies &c.

PREPARED AND SOLD

WHOLESALE AND RETAIL

BY the PROPRIETOR,

READING.

This Sauce is generally used at Table with all sorts of Fish, in preference to all other Fish Sauces, and is esteemed peculiarly delicious with Game, Wild Fowl, Hashes, Rump Steaks and Cold Meat.

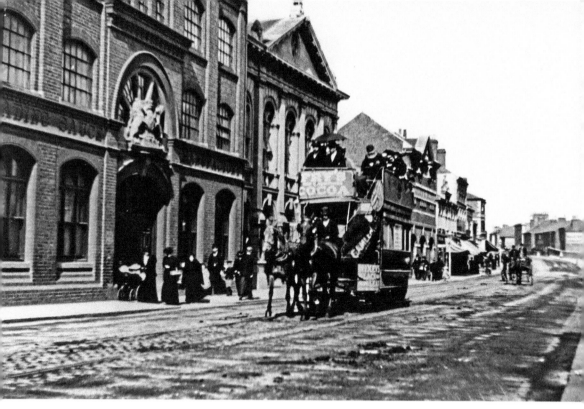

Kings Road in 1900. The Cock's Sauce factory (left) stands on the site now occupied by the Central Library. The horse trams in the picture would soon be replaced by electric ones (1214363).

in 1878, on land they had acquired many years earlier, and where they made sauce in 75-gallon casks obtained from Simonds Brewery.

Over the years they diversified into all sorts of luxury foodstuffs, both sweet and savoury. But gradually their market share declined as they failed to match the marketing effort of rivals like Lea & Perrins. The Cocks family sold the business in 1900 and production finally ceased in 1962. Efforts have been made in recent years to revive the product.

Anyone wanting to know more about Mr Cocks and his sauce is directed to the article in the *Berkshire Archaeological Journal* (volume 70), 1979/80.

Tilehurst – What's in a Name?

There seems to be a bit of a mystery surrounding Tilehurst's name. Its meaning is quite clear: it comes from two Old English words, *tigel* – a tile – and *hurst* – a wooded hill. But why was it called that? The earliest written reference to the place was in 1291, when Pope Nicholas III and his tax collectors listed it as a hamlet of Reading (written reference to the local church, St Michael's, goes back even further, to a charter granted by the Bishop of Salisbury between 1189 and 1193). But records of a local tile-making industry only go back to the sixteenth or seventeenth centuries, and it only seems to have become a major part of the local economy in the latter part of the nineteenth century. So why was it originally so named?

In its heyday, the tile and brick making industry certainly had a physical impact on the area. Clay was dug at the area still known as Norcot Potteries and transported by overhead cableways around a mile and a half to the tile-making works at Grovelands. Where the cableway crossed roads nets were slung underneath it, to stop the clay falling on the roads. The peak of production was actually reached in around 1885, but by 1936 over 20 million items a year were still being produced. They roofed some distinguished buildings, including the Prime Minister's house Chequers, a Cambridge College and the Middle Temple in London. But by the 1960s the industry was in decline, with labour shortages a particular problem. The pits were closed by 1967. Today, one of the area's most prominent landmarks is the 120 foot high water tower, built in 1932 to supply all the housebuilding going on in the area, and visible from miles away.

From the earliest days to the dissolution of the monasteries the area was owned by Reading Abbey. It was then leased to a prominent local family, the Englefields, from 1545 to 1585, when Francis Englefield was attainted for his Catholicism and his lands confiscated. (Attainder was a vicious political weapon that enabled the powers that be to use a parliamentary Act to circumvent the accused's right to a fair trial and the rules of evidence.) Other leading families connected with the area over the years included the Vanlores and Zinzans (*see* under section Z), the Kendricks and the Childs.

Tilehurst only became a part of Reading Borough in 1911 but was effectively a suburb of Reading well before that. From 1887 a daily horse-drawn carrier service

provided public transport between Tilehurst and Reading. Some of them would even do customers' shopping for them. There was a twice-daily horse bus service from 1899 or earlier and petrol buses from the 1920s. Between 1936 and 1968 the same journey was served by trolley buses and in 1882 Tilehurst got its own railway station, though this was always very much subordinate to Reading's central station.

Part of Tilehurst has an unexpected link with the exotic east. In the 1920s, part of the Royal Berkshire Regiment was stationed at a hill fort near the Indian–Tibetan border, at a place called Ranikhet (the term translates from Hindi as 'Queen's meadow'). The name was reused when a new army camp was established off Church End Lane in 1940, to complement the wartime facilities at Brock Barracks (*see* section R). For 18 months from 1943 the camp was occupied by American forces, then by prisoners of war and finally by some 80 homeless families, who squatted in it during the post-war housing shortage. From 1954 it was home to the Army Pay Corps, before being redeveloped from 1960. Today, the Ranikhet School occupies the former site of the camp. The Chinese dragon on the school badge is a reminder of the Royal Berkshire regiment (as they would become) and their part in the Chinese opium wars of the 1840s.

People wanting to know more about the area should look at the books by Sue Handscombe.

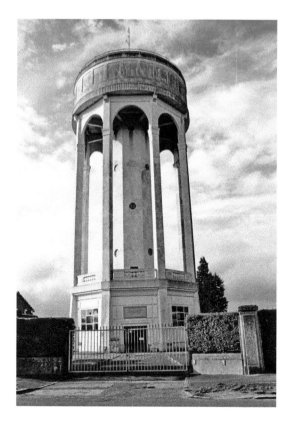

A striking garden ornament for someone: the Tilehurst water tower, built in 1932 to serve the new development in the area (Wikipedia).

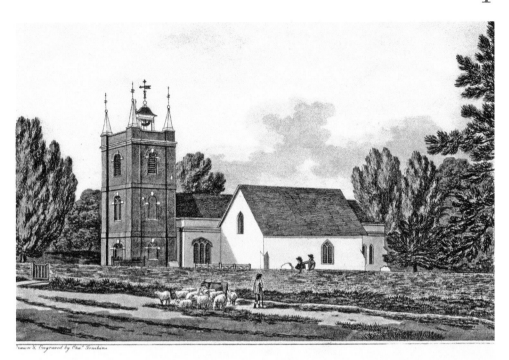

TILEHURST CHURCH.

St Michael's Church, Tilehurst, before its 1850s makeover (1208332).

The Potteries development, built where once the clay for Tilehurst's staple industry was extracted.

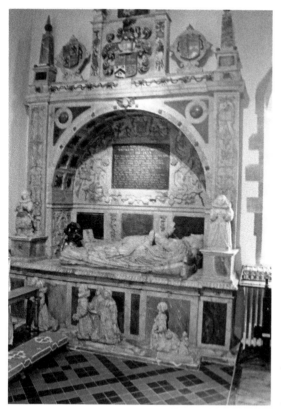

Left: The grand monument in St Michael's Church, Tilehurst, commemorating the Vanlore family, once lords of the manor of Tilehurst.

Below: The horse-drawn bus that ran between Tilehurst and Reading, seen in 1900 at the junction of Kentwood Hill and Norcot Road (1300690).

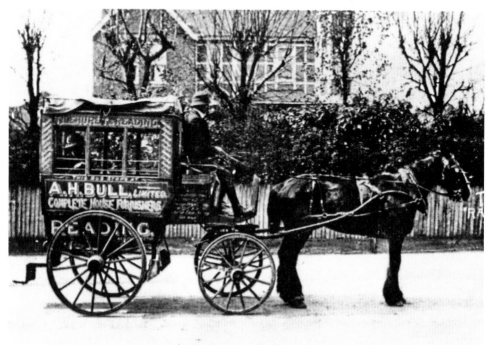

University of Reading

Today the University of Reading is a place of learning that is highly regarded nationally and internationally. We will look here at how it came into being.

Reading's first association with university life goes right back to the year 1209, and was both brief and unhappy. In that year the murder of an Oxford woman, followed by the summary lynching of some students thought to have been responsible for it, escalated into the university being driven out of Oxford. Part of it settled in nearby Reading. No one seemed pleased with this arrangement. As one observer put it, 'the students were poor, hungry and riotous, the townsfolk sullen and grasping'. All parties were doubtless relieved when the university was re-established at Oxford in 1214.

The modern university's roots lie in the Schools of Arts and Science, established in Reading in 1860 and 1870, respectively. The Arts School started life in West Street, while the sciences were on the site now occupied by the museum and art gallery. Their establishment coincided with a campaign for liberalisation within Oxford University, aimed at spreading the benefits of higher education more widely. Under this, women, Nonconformists and the less well-off could all now benefit from a university education, and this even extended to the denizens of benighted outposts like Reading. Christ Church College, Oxford, opened an extension college in Reading in 1892 and, that same year, Reading transferred the Schools of Arts and Sciences to their keeping.

The establishment's resources were not yet up to university standard. According to one report the college's library in 1908 consisted of a single bookcase and it was a continual battle to find wealthy benefactors to rescue them from imminent financial disaster. Nor was the syllabus exactly academic. Only a handful of the students were potential graduates – many of the others were studying things like shorthand and typing, hygiene, wood carving and needlework. They did at least develop a national reputation for agriculture, and they even had their own 140-acre classroom from 1904 – a farm at Shinfield.

Even so, they soon outgrew their premises and biscuit manufacturer George Palmer came to their rescue with the gift of a 6-acre site in London Road, along with a £50,000 building fund. Palmer's generosity did not go down at all well with his

biscuit-making employees, who had been suffering short-time working and layoffs in a difficult business climate. It was one of the factors behind the company's first ever wages strike.

The First World War nearly finished the college off, as almost all its accommodation was taken over for war-related training. But it recovered and (partly thanks to the Privy Council applying a rather flexible interpretation of its own criteria for university status) in March 1926 Reading became the only college to be given university status between the two world wars.

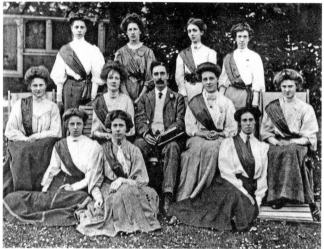

Above: Reading University Extension College's premises on Valpy Street, seen in 1905 from St Laurence's churchyard (1431023).

Left: Dr William Childs, principal of the University College and a driving force behind it gaining full university status in 1926. He is seen here in 1908 with a group of female students (1431041).

Lord Goschen, the Vice-Chancellor of Oxford University, lays the foundation stone of the University College's Great Hall in June 1905.

The old abbey hospitium, and later part of Reading University College's Valpy Street buildings, seen today from St Laurence's churchyard (1431045).

The Acacias, formerly the Palmer's family home and, from 1906, part of the London Street campus of the Reading University College.

V

Vachell – the Family and the Road

The Vachells (or Vachels) are one of Reading's oldest aristocratic families. For 418 years they owned the estate still known as Coley Park, and they have held many official positions in the town, from jurors for the Borough of Reading at the Assizes of 1261, to Deputy Commissioner overseeing the dissolution of Reading Abbey, High Sheriff of Berkshire, and Members of Parliament. They first became associated with the Coley Park estate in 1309, when John Vachell bought it from one Thomas Syward. (The family also owned many other estates in the area.)

The family's original surname was De La Vache (of the cow?) and their unusual family motto – 'It is better to suffer than to revenge' – was apparently imposed upon them as part of the punishment for a fourteenth-century dispute with the abbot of Reading over a right of way. John Vachell chose to resolve this dispute by the rather radical means of murdering a monk who conducted an exploratory trespass along it. He was also excommunicated, had part of his estate confiscated and was heavily fined for the deed.

Thomas Vachell (1480–1553) served as MP for Reading and as deputy to Thomas Cromwell and Doctor John London in the posts of Overseer of Abbey Property and Bailiff of Reading. His superiors were two of the driving forces behind the Dissolution of the Monasteries nationally and, among his other duties, Thomas was keeper of the abbey plate and other valuables. The locals did not like him; they told his superiors that he was 'not their friend' and did not have their trust. But he survived even Cromwell's fall from royal favour, coming away with some valuable deals on abbey property (such as buying the roof of the abbey library for £6).

The family were in trouble again in the sixteenth century, when another Thomas Vachell (1537–1610), a staunch Catholic, earned himself a fine equivalent to £5,500 in modern values for recusancy in 1588, after he failed to worship at the established church for a year (as was required by law). He narrowly avoided having the family's entire estate confiscated.

During the Civil War and its run-up the Vachell family's loyalties were divided, with yet another Thomas Vachell being a Royalist, while Tanfield Vachell, strongly influenced by the prominent Parliamentarian John Hampden (into whose family the

Vachells had married), supported the Parliamentary cause. Tanfield was a member of the Parliamentary Committee for Berkshire, one of whose jobs was weeding out Royalist sympathisers.

After the Civil War the family home was in a bad state and Tanfield set about rebuilding it in the 1650s. He surrounded it with huge (and at that time fashionable) geometrical flower beds and fishponds. The house remained in the family until 1727, by which time the estate was so heavily encumbered that the then occupier, William Vachell, had no choice but to sell it. Four centuries of Vachells at Coley came to an end.

Today, the family's physical presence in the town includes the almshouses in Castle Street bearing their name, a font in St Mary's Church with the family crest, along with the family tomb, and the modest Victorian street off Greyfriars Road. To follow the rather complicated Vachell family tree in more detail, go to www.coleypark.com.

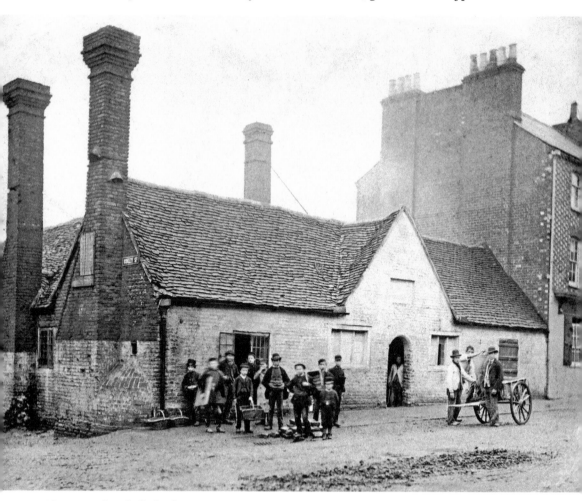

The original Vachell almshouses, erected in 1634 and demolished before 1863. Their Victorian replacements are not quite on the same site (1323282).

Vachell Road, named after the long-established, leading Reading family.

A surprisingly modest monument to no less than fourteen members of the Vachell family, who inhabit a vault under the floor in an obscure corner of St Mary's Minster Church.

The White Ship Disaster

The event that arguably had the greatest impact on Reading's early history occurred not in the town itself, but off the port of Barfleur in Normandy on the night of 25 November 1120. Henry I, the youngest son of William the Conqueror, was at the height of his powers in 1120, ruling over both England and Normandy. He had been in Normandy putting down a rebellion and was preparing to return to England when he was approached by a ship's captain named Thomas Fitzstephen. Fitzstephen claimed to be the son of the captain who had safely carried William the Conqueror across the Channel in 1066, and offered the same service to Henry.

Henry had already made his travel arrangements, but entrusted Fitzstephen with the carriage of his only legitimate son and heir to the throne, William Adelin. Before setting sail William and his entourage plied Captain Fitzstephen and his crew with large quantities of strong drink and by the time they were ready to leave, night had fallen and both crew and passengers were roaring drunk. Some were too drunk to get on board.

Barfleur was a difficult port to navigate at the best of times and the ship struck a submerged rock and began to sink rapidly. Of the 300 people on board, only one survived. It was said that Captain Fitzstephen chose to drown rather than face the wrath of the king, for among those who perished were William Adelin and a number of King Henry's illegitimate offspring. It was said that Henry never smiled again after receiving the news. But it was not just a personal tragedy. William's death left a disputed succession and led the nation into a long period of civil war, known as the Anarchy, in which two of William the Conqueror's grandchildren, Stephen and Matilda, fought over the throne.

Henry decided to commission a huge abbey in commemoration of his son and Reading was chosen as its location. It would dominate the life of the town for the next 400 years, making it one of the most important religious centres in the land. Henry would not live to see its completion, but is buried within its precincts – somewhere (*see* section X of our A to Z).

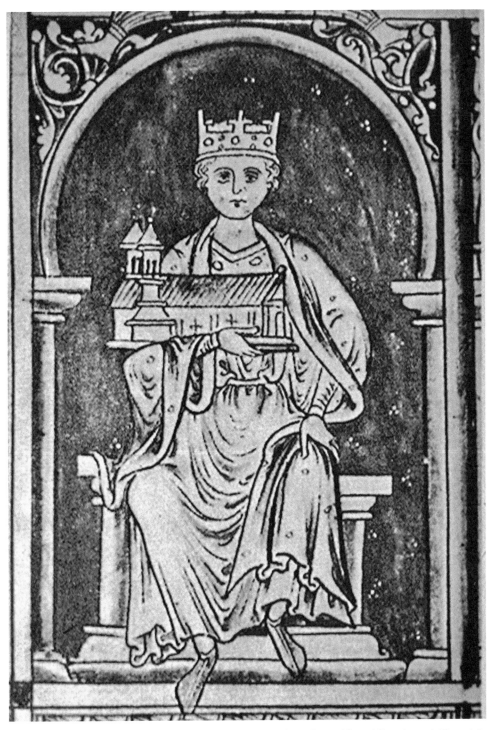

An early picture of Henry I, shown holding a model of Reading Abbey. (Illuminated Chronicle of Matthew Paris, 1236–59.)

X Marks the Spot – but Where's King Henry?

Henry I commissioned and endowed Reading Abbey – he laid the foundation stone in 1121 and signed the foundation charter on 29 March 1125 – but he did not live to see it completed. He died in France in 1135 from eating 'a surfeit of lampreys' (a variety of eel) and his body was sewn into a bull's hide for the journey back to Reading. There he was buried in front of the high altar of the as yet incomplete abbey. A life-sized monument to his memory was created there, at the time or soon afterwards; we know this because in 1398 Abbot Richard Yateley was told by the then royal family that he must 'within a year honourably repair the tomb and the effigy of Henry Beauclerc over his place of burial'.

Legend had it that Henry had been buried in a silver coffin within a stone sarcophagus. Come the Dissolution of the Monasteries and iconoclasts were keen to get their hands on it. They smashed up the tomb and opened up the grave, and finding nothing of value, scattered its contents to the four winds.

At least, that is one account of events. Others believed Henry remained safely interred, waiting to be found. In 1793, as the foundations of Reading Gaol (the prison before the present one) were being dug, an elaborate lead coffin containing a perfect skeleton and traces of leather (the remains of a bull's hide?) was dug up on what was thought to be the site of the destroyed Lady Chapel. The antiquaries of the day jumped to the conclusion that it was Henry, but it was in the wrong place and modern scholarship suggests it was more likely the remains of one of the former abbots.

Then in November 1815 part of a large elaborate stone sarcophagus was found, exactly where Henry was thought to have been buried. It appeared to be the right age and to belong to someone of high status. It had also suffered damage from violent handling and hasty reinterment. But there was no sign of the occupant.

In 1921, to mark the 800th anniversary of the abbey's foundation stone being laid, a memorial tablet to Henry Beauclerc was unveiled by the dean of Winchester in the abbey ruins, supposedly to mark the spot where Henry was buried – or somewhere near it. But, almost a century later, they are still looking for him.

The Burial of King Henry I. at Reading Abbey, January 4th, 1136.

(ABBEY SERIES NO. 1.)

. *Presented by*
Dr. J. B. Hurry.

By H. Morley,
Exhib. R.A. 1916.

A painting depicting the funeral of Henry I in the incomplete Reading Abbey on 4 January 1126 (1157957).

The Beauclerc Cross, erected in the Forbury Gardens in 1909, 'somewhere near' where Henry I was thought to have been buried.

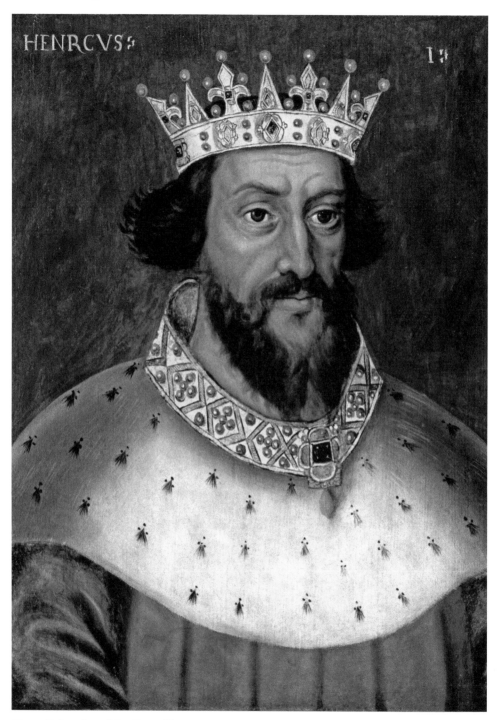

Henry I, founder of Reading Abbey. Contemporary portraits cannot always be relied upon for a reliable likeness of the sitter. Rather they tended to concentrate on portraying their status (Spartacus Educational).

Modern archaeologists exploring the abbey site using ground penetrating radar in September 2016 have discovered bodies behind the site of the high altar. Once again hope springs that Reading will do as Leicester did and be able to reinter their resident royalty with the appropriate pomp, though the odds seem heavily stacked against it. Henry preceded Richard III by more than three centuries, making the likelihood of establishing a DNA link over almost a thousand years even more tenuous than in Richard's case.

Yield Hall and the Travelling Seat of Local Government

The earliest recorded home of local government in Reading was in a Yield Hall (or Guildhall) on Yield Hall Lane, near to the River Kennet where the Oracle now stands. Its main drawback was that it was also where the town's housewives gathered to wash their clothes in the river and exchange gossip. Their voices, and the sound of them beating their washing with wooden implements called battledores, drowned out the deliberations of the town's elders. The building was also too small for their needs.

On 5 February 1540, Henry VIII leased the Greyfriars Church lands (newly disestablished) to his servant Robert Stanshawe (after whom Stanshawe Road is named – part of it was later sold to Tanfield Vachel, from where we get Vachel Road). But Henry reserved his ownership of the church building itself. Two years later and a new charter for the town from Henry gave the Corporation the use of part of the Greyfriars Church building as the new guildhall. At this time, the Guildhall was in debt – possibly due to the cost of converting it from a church. Loans had to be taken out and other measures taken to get the finances back on an even keel. These included fining any member who did not turn up for meetings dressed 'in his gowne decently'.

A further royal charter, from Elizabeth I in 1560, gave the Corporation the right to continue using the church as a guildhall, or to dispose of it for other uses. This enabled the mayor and burgesses to relocate the Guildhall again in 1578. This time, it was to the former hospitium of Reading Abbey, which, sometime before the dissolution, had been converted into a home for the grammar school (the future Reading School). The Corporation fitted an extra upper floor into the school building as a council chamber – an arrangement that was to suit neither party.

Nonetheless the arrangement continued until 1785, by which time the old abbey building was showing signs of structural failure. The Corporation commissioned a new building, at a cost of £1,800. But the designer was one of their own, Alderman Charles Poulton, and he was a cabinet maker, not an architect. However, the building

Yield Hall Lane in 1975, seen from the top of the multistorey car park that stood there for many years (1427655).

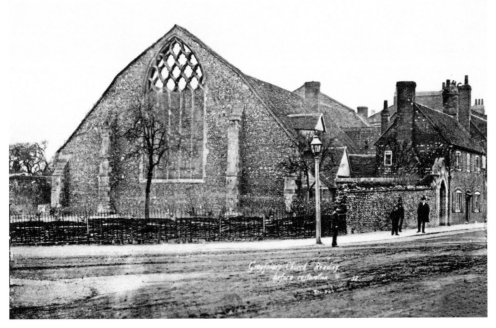

Greyfriars Church, seen here in its derelict pre-Victorian restoration state. For a time it was the home of Reading's local government, following its dissolution as a place of worship in 1538 (1152735).

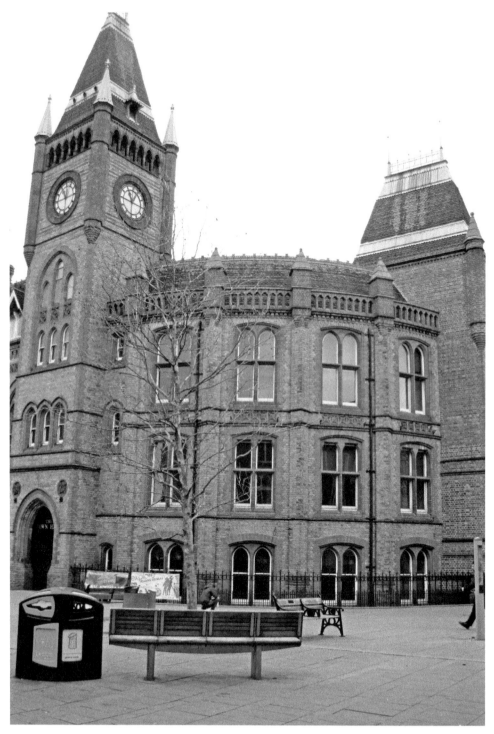

The Alfred Waterhouse part of the old Town Hall is part of a complex built in four phases by three different architects (and a cabinetmaker) over more than a hundred years.

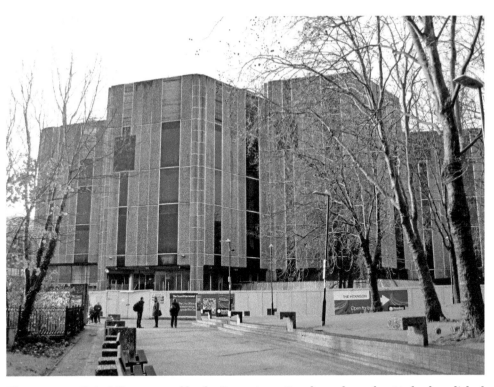

The post-war Civic Offices, opened by the Queen in 1978 and seen here about to be demolished in 2016.

The hole in the ground that was the Civic Offices, waiting in 2017 for a new occupant and opening up an unfamiliar view of the Hexagon.

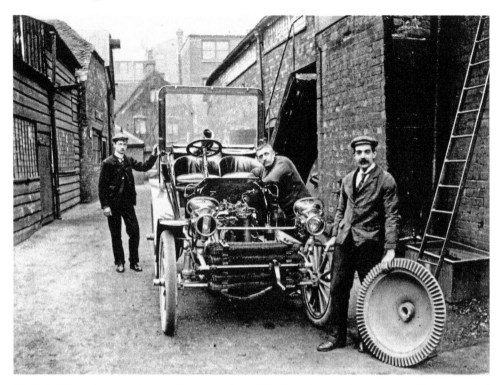

Yield Hall Lane in around 1910. All traces of a guildhall are by now long gone and it is occupied by Wilders, who were iron founders and – it would seem – early car mechanics (1301152).

survives to this day as the Victoria Hall, the oldest part of a town hall complex designed by four different people over the course of more than a hundred years. Phase two was by the famous architect Alfred Waterhouse, in 1875. Waterhouse also competed to build phase three but, when his entry proved to be too expensive for the Corporation's tastes, the judge of the competition, one Thomas Lainson, awarded the contract to himself (1882). The final phase, dating from 1897 and housing the museum and art gallery, was by W. R. Howell.

The premises were still too small for the council's growing needs and the search began almost immediately for a new site. The search lasted over seventy years and, after ruling out the Forbury Gardens, London Road, Reading Prison, Hills Meadow and Prospect Park, a new civic centre was built at the west end of the town centre and opened by the Queen in 1978. This lasted until 2014, by which time the building was beyond economic repair. That site is currently a hole in the ground awaiting redevelopment, and the council is currently to be found at Plaza West, on Bridge Street.

Z

Zinzan – the Family and the Street

People walking out of the town centre along the Oxford Road may have been puzzled as they passed the name Zinzan Street. Who or what was a Zinzan?

The Zinzans are a family of Italian origin. The earliest in the line was thought to be one Hannibal Zenzano, who was recorded as being a farrier to Henry VIII in 1514. The equestrian theme continued with a Robert Zinzan, an equerry in the royal stables during the reign of Elizabeth I. He was a regular participant in tournaments at court

Zinzan Street, named after the family of Italian origin that played an important part in the life of Tilehurst. The street is now part of a conservation area.

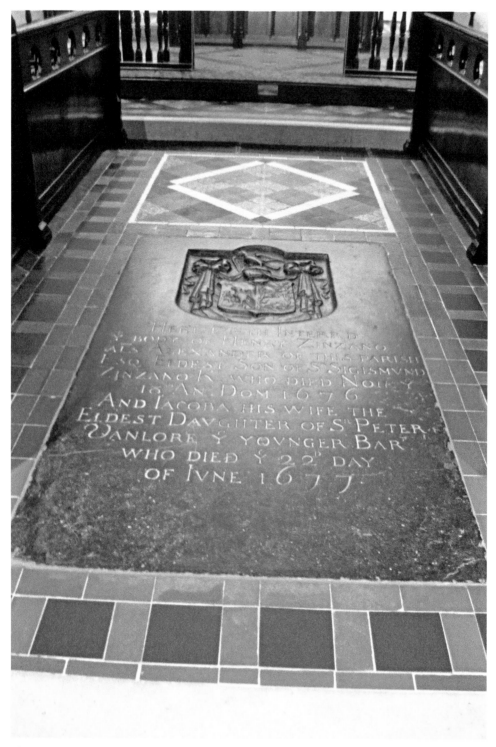

The monument to Henry Zinzan in St Michael's Church, Tilehurst.

between 1565 and 1591 and was knighted by King James in 1603 (under the name of Sir Robert Alexander, an anglicised name the family often adopted).

But the Zinzan in which we are most interested was Henry, Robert's grandson. Born in around 1600, he married Jacoba, the eldest daughter of Sir Peter Vanlore, who held the manor of Tilehurst.

Vanlore (c. 1547–1627) was a Dutch-born merchant, jeweller and moneylender who came to England aged around twenty-one. His jewellery business soon became established in the highest circles, with patrons including Elizabeth I and James I. He diversified into banking and was able to help out his royal patrons on various occasions (albeit generally making a profit from these royal 'favours'). In around 1604 he acquired the manor of Tilehurst and established a manor house at Calcot as his country seat. Calcot Park (now a golf course) was part of their estate. This was just the start of his extensive landholdings in Berkshire, which included Sonning (1625) and Wallingford Castle. He was naturalised in 1610, knighted in 1621 and died in 1627.

Vanlore's son and daughters were joint heirs to his estates, but it seems that by 1676 the descendants of Peter Vanlore had reunited ownership of the entire manor.

Both Sir Peter Vanlore and Henry and Jacoba Zinzan are buried at St Michael's Church, Tilehurst. Vanlore has a magnificent renaissance monument, but Zinzan's tomb was hidden for 150 years.

About the Author

Stuart Hylton was born in Windsor, studied at Manchester University and has lived in Reading since 1980. He has had some twenty-five books on historical subjects, local and national, published in that time, including several volumes on the history of Reading. He is married with two grown-up sons.

Also available from Amberley Publishing

READING 1800 TO
THE PRESENT DAY

THE MAKING OF MODERN READING

STUART HYLTON

A thematic approach discussing why Reading has become the town it
is today.

978 1 4456 4831 6
Available to order direct 01453 847 800
www.amberley-books.com

Also available from Amberley Publishing

READING IN 50 BUILDINGS

STUART HYLTON

Explore the rich and fascinating history of Reading through an
examination of its greatest architectural treasures.

978 1 4456 5934 3

Available to order direct 01453 847 800

www.amberley-books.com